CHARACTER DESIGN QUARTERLY

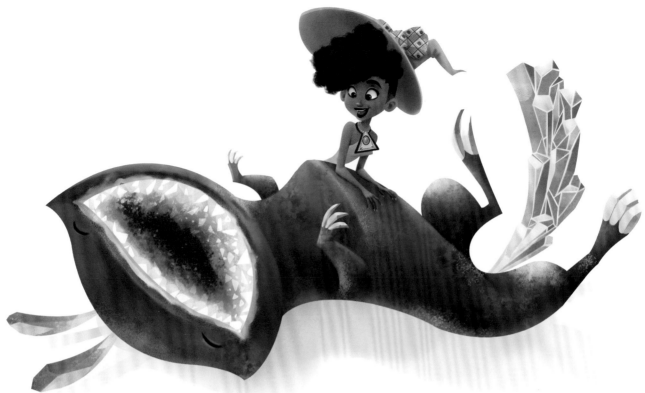

CONTENTS

WELCOME TO *CHARACTER DESIGN QUARTERLY 16*

Hello and welcome to our spring edition – packed with insight, advice, and talent from incredible artists. My particular favorite this issue has to be Raquel Villanueva's poignant grandfather figure, set in a scene full of dreamy storytelling. You can imagine a whole life lived in that image, and she tells us step by step how to achieve it. Another meditative image is our gorgeous cover this time around, with stunning lighting effects created by Devin Elle Kurtz – I just want to dive into that ocean!

We also speak to an old friend, James A. Castillo, about the past two years of his career – and of the global situation in general. Things have certainly changed, but James is excitingly optimistic about the future of animation and the art industries in general. It was inspiring to catch up with him.

I wish once again for you to sit back for a while, forget about the outside world, and lose yourself in the fantasy and beauty on these pages. And I hope you can pick up a few new essential pieces of knowledge while you're doing it.

Enjoy!

SAMANTHA RIGBY
EDITOR

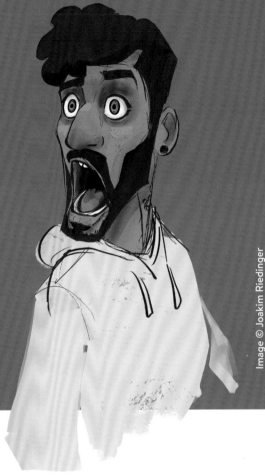

Image © Joakim Riedinger

BEHIND THE COVER ART:
DEVIN ELLE KURTZ

This issue's cover has been designed by the incredibly talented Devin Elle Kurtz. On the next few pages she tells us about her breakthrough into the animation industry, and how she balances her in-house role with her own projects. You'll also find a detailed tutorial covering the process of how she created the stunning cover art. Read on to be swept into Devin's magical world, full of light, wonder, and inspiration.

Hi Devin, thank you so much for creating such an enchanting cover for this issue. Could you tell us a bit about yourself?

Hello and thank you for having me! Well, I have wanted to be a professional artist since I was about 11 years old. My earliest inspirations were TV shows and movies like *Avatar: The Last Airbender*, *Pokemon*, and *Princess Mononoke*. I moved to LA for college when I was 17, but ended up dropping out at 18, deciding to pursue my freelance career instead. At the age of 20, I began working on the Matt Groening show *Disenchantment*, and have been on that production ever since. Now I'm 23 and I balance my role as the lead background painter on the show with my own personal projects.

Dropping out of college and pursuing a career so young was a big step. How did you manage it?

I'm lucky to have amazing friends, both online and in person, who have always supported me and encouraged me to trust my gut and follow my dreams. When I dropped out of college, I was able to move into my boyfriend's mom's house to save up some money before I found my own place. My parents are both artists – my father is a photographer and my mother is a graphic designer – so they have always been incredibly supportive. It's that type of kindness and generosity that allowed me to find my path, and I hope I can do the same for others someday.

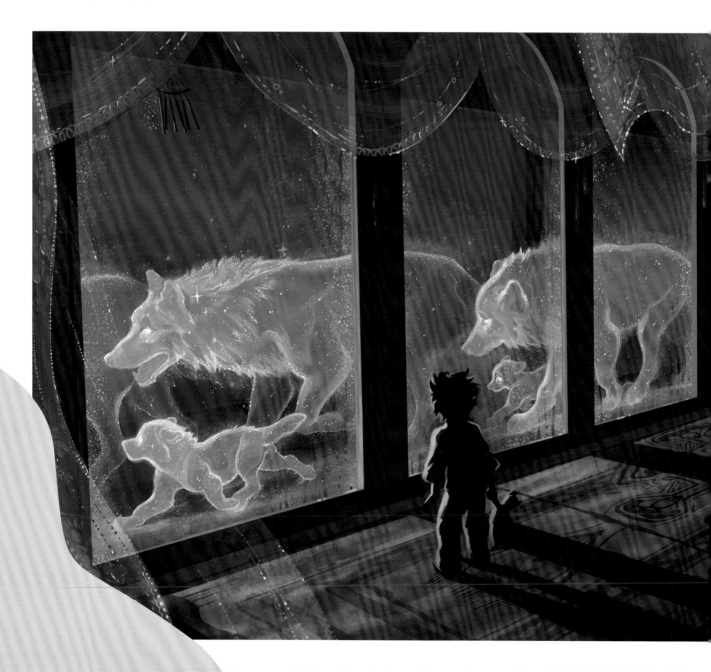

"IT'S KINDNESS AND GENEROSITY THAT ALLOWED ME TO FIND MY PATH..."

Opposite page: *Chasing the Mermaid* – the mermaid doubles back for the brothers as they race down the hallway together

This page: *Pillow Fort Research Outpost* – brothers construct a pillow fort to observe a glowing whale shark

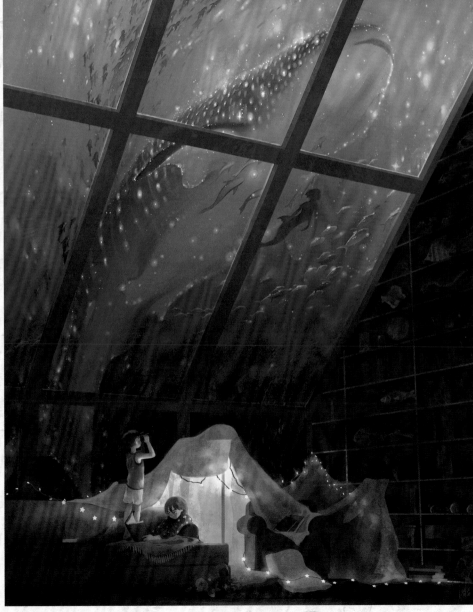

Your work is full of magic and whimsy. You mentioned being inspired by classics such as *Princess Mononoke*. Where else do you get the inspiration for such breathtaking designs?

I've always been open about my inspirations, and bring as much admiration and attention to the media as I can. Something that has inspired me greatly is the manga series, and subsequent animated film, *Children of the Sea* by Daisuke Igarashi. Two non-animated inspirations were the movies *Beasts of the Southern Wild* and *Where the Wild Things Are*. You might be able to tell, I have a connection to stories about children who go on magical adventures. These are themes and feelings I've tried to recreate in my own artwork.

We love how you use light within your designs to help tell your stories. What led you to include this dramatic design element, and was it difficult to master?

I have always been drawn to vivid colors and assertive compositions. I love to play with scale and light to create a sense of wonder and majesty. I love art and media that create an experience of childlike awe – that feeling of seeing something in life for the very first time, which tends to become rarer as we get older. Light, in my experience, is one of the elements that helps to generate that kind of deep, emotional reaction.

This page: *Fyogan Workshop* – the young necromancer works to reconstruct a cat's skeleton to add to his reanimated army of felines

Opposite page: *Fyogan Greenhouse* – a young necromancer waters his plants and gives one of his cats some well-deserved love

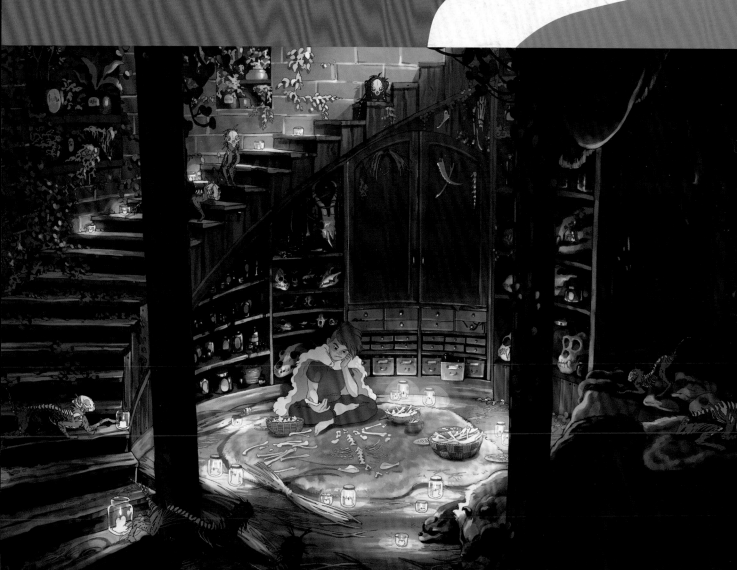

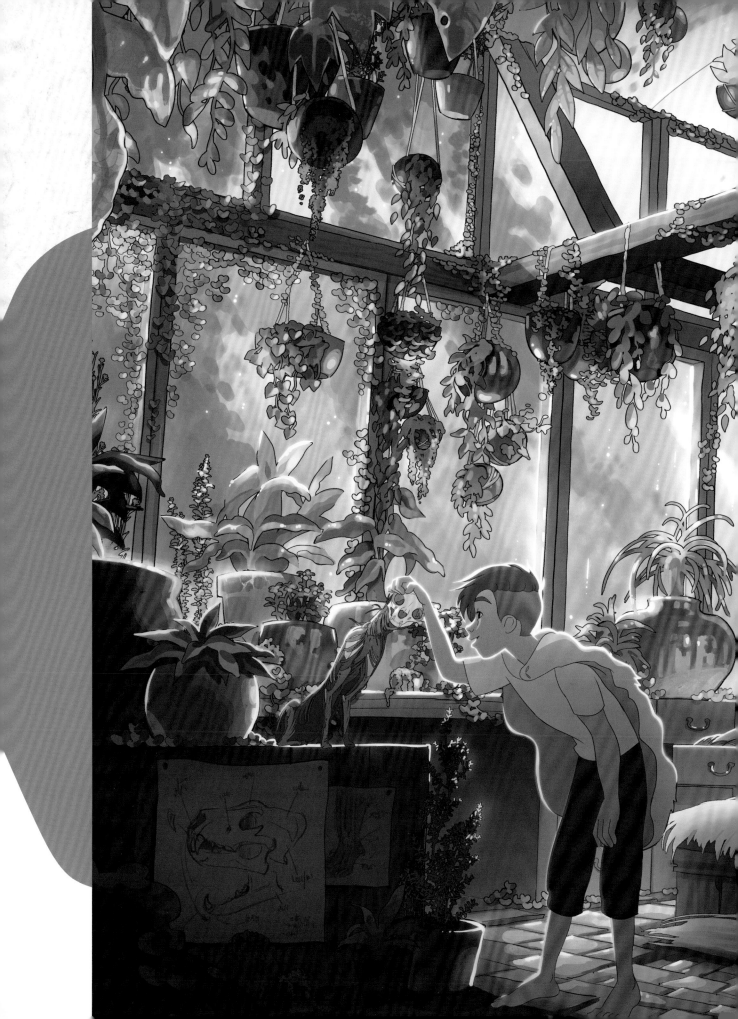

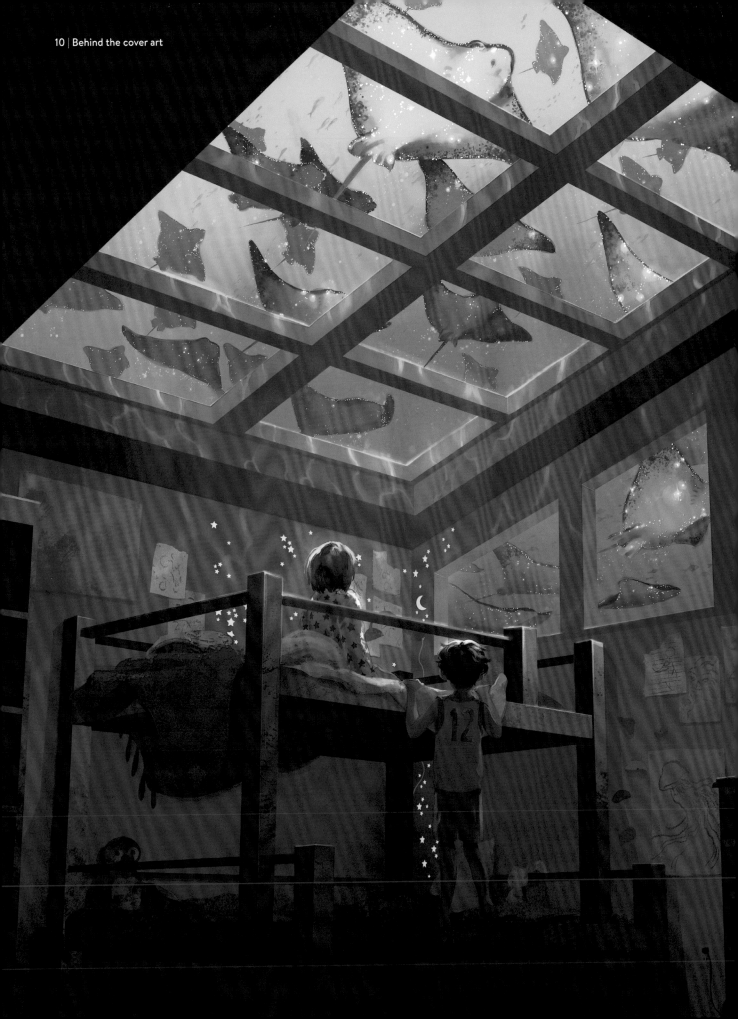

What are the big differences between your in-house and freelance work? Do you find it difficult to balance them?

Working in-house at a studio has been a wonderful experience. The long-term and close-knit nature of a TV production allows for amazing friendships and growth alongside other artists. Freelance is wonderful in its own way, because it allows me to work with clients all over the world, and to have a great variety of experiences, since it's often more short-term projects. I really love doing both types of work. I try to keep a balance by using a whiteboard to keep track of important deadlines, and by ensuring I always get enough sleep, exercise, time off, and healthy food to avoid burnout.

What have been your favorite projects to work on so far? And what should we look out for in the future?

I have always enjoyed working with artistic communities such as DeviantArt. I've made some amazing friends at the company, and working with the website that helped launch my career is wildly inspiring for me. Working with them, I created a banner for SyFy, which was displayed on the front doors of New York Comic Con in 2018 – that was incredible. Right now I'm working on a very cool game project called *Kindred Fates*, as an environmental concept artist. If anyone has checked out my Artstation and enjoyed my Titan Pokemon fanart series, I think they should be really excited about this upcoming project.

Opposite page: *Unusual Night* – two brothers discover an odd phenomenon surrounding their underwater house when they wake up after midnight

This page (left): *The Outsider* – a girl longingly watches ballerinas run to their ballet recital through a window

This page (right): *Shining Signal* – the brothers switch on a flashlight at just the right moment to catch a glimpse of a mermaid for the first time

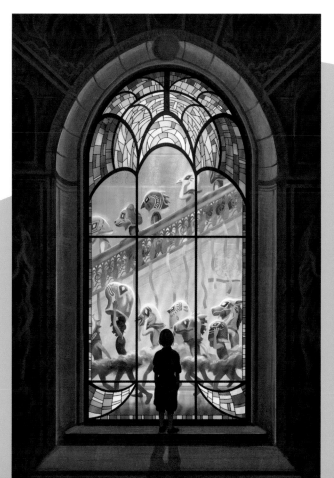

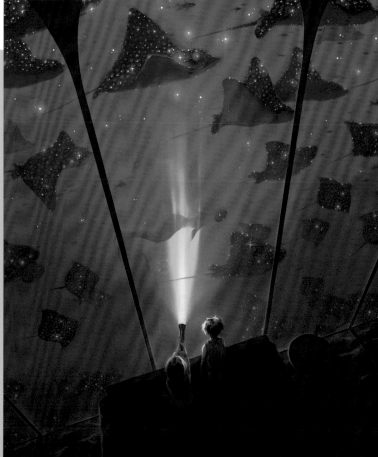

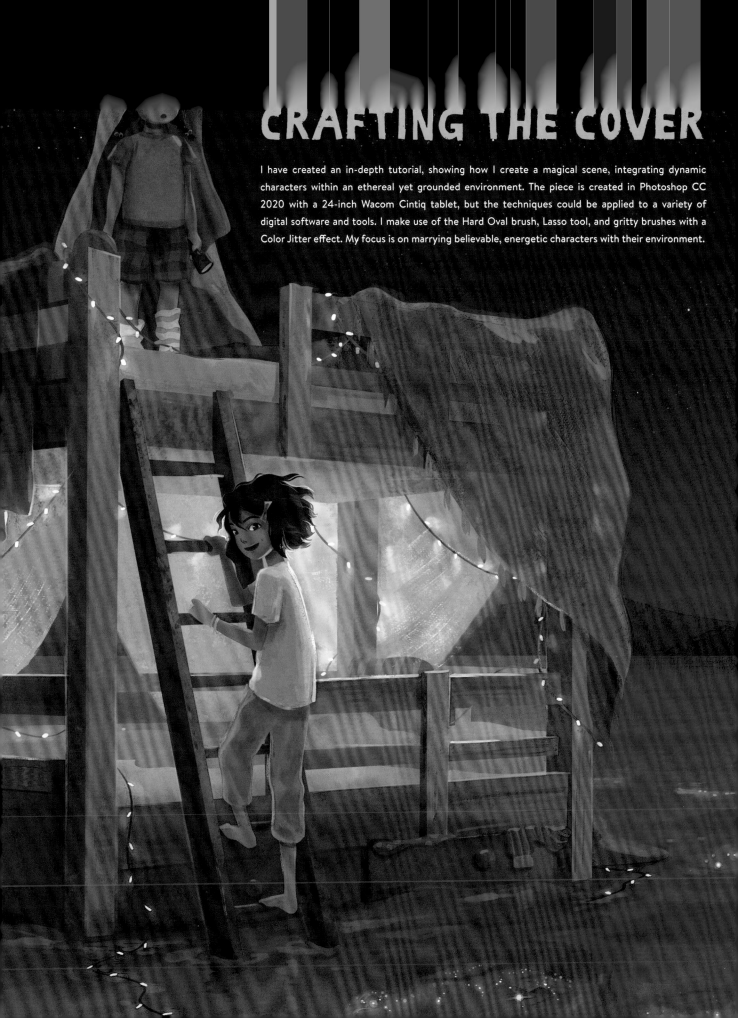

CRAFTING THE COVER

I have created an in-depth tutorial, showing how I create a magical scene, integrating dynamic characters within an ethereal yet grounded environment. The piece is created in Photoshop CC 2020 with a 24-inch Wacom Cintiq tablet, but the techniques could be applied to a variety of digital software and tools. I make use of the Hard Oval brush, Lasso tool, and gritty brushes with a Color Jitter effect. My focus is on marrying believable, energetic characters with their environment.

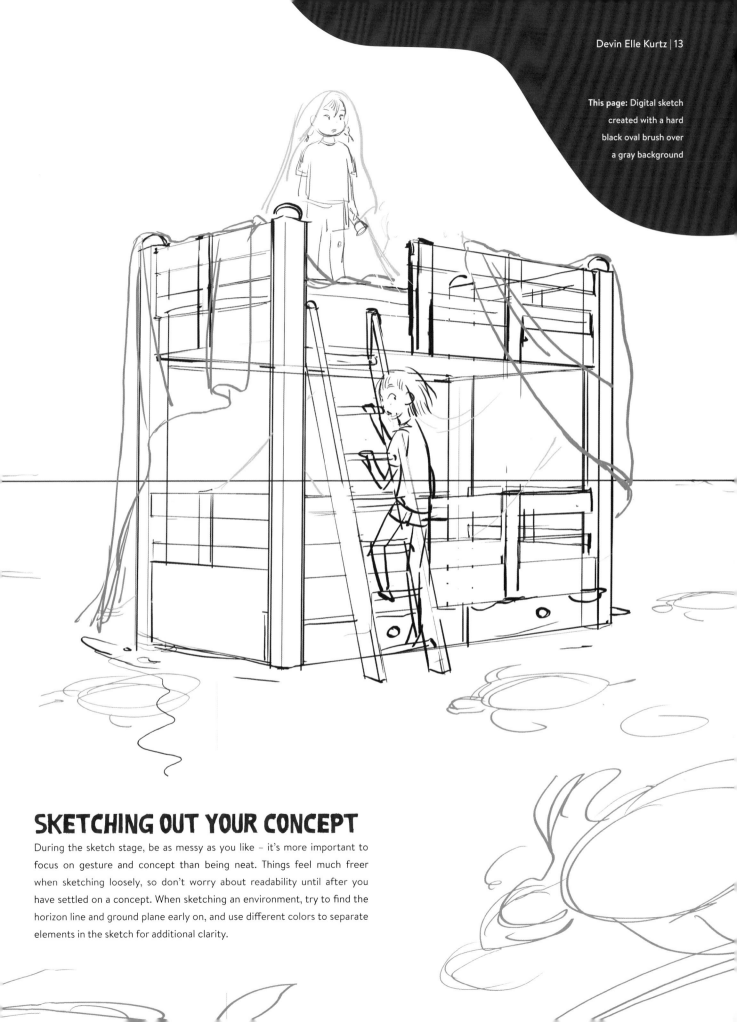

This page: Digital sketch created with a hard black oval brush over a gray background

SKETCHING OUT YOUR CONCEPT

During the sketch stage, be as messy as you like – it's more important to focus on gesture and concept than being neat. Things feel much freer when sketching loosely, so don't worry about readability until after you have settled on a concept. When sketching an environment, try to find the horizon line and ground plane early on, and use different colors to separate elements in the sketch for additional clarity.

COLOR THUMBNAILS

After the concept is nailed down, it's time to explore the options for color. Initially, it's a good idea to go with instinct and paint it the way that feels most natural. Try to keep the layers organized, separated, and clearly labeled – this makes it easier to adjust each element in additional thumbnails, using color balance and other adjustment layers. When exploring options, try to create a variety of differences from the original thumbnail – you might be surprised by what you come up with.

"TRY TO CREATE A VARIETY OF DIFFERENCES ... YOU MIGHT BE SURPRISED BY WHAT YOU COME UP WITH"

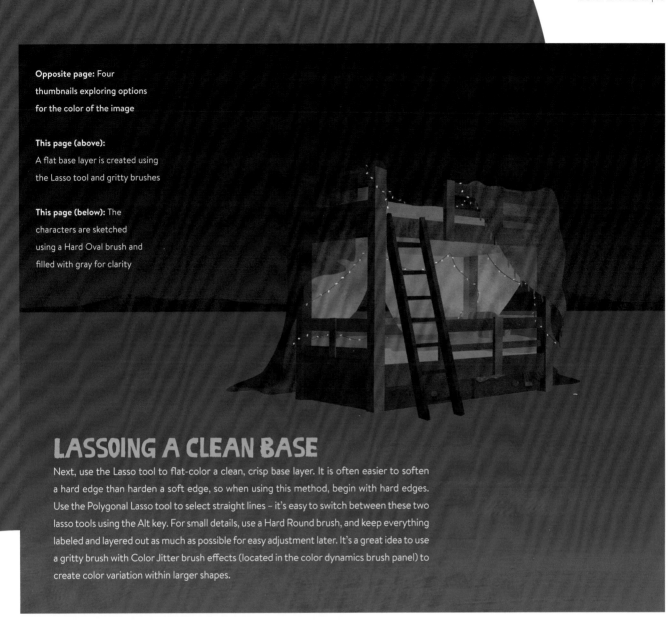

Opposite page: Four thumbnails exploring options for the color of the image

This page (above): A flat base layer is created using the Lasso tool and gritty brushes

This page (below): The characters are sketched using a Hard Oval brush and filled with gray for clarity

LASSOING A CLEAN BASE

Next, use the Lasso tool to flat-color a clean, crisp base layer. It is often easier to soften a hard edge than harden a soft edge, so when using this method, begin with hard edges. Use the Polygonal Lasso tool to select straight lines – it's easy to switch between these two lasso tools using the Alt key. For small details, use a Hard Round brush, and keep everything labeled and layered out as much as possible for easy adjustment later. It's a great idea to use a gritty brush with Color Jitter brush effects (located in the color dynamics brush panel) to create color variation within larger shapes.

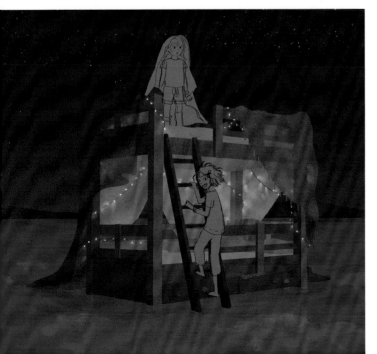

CHARACTER DETAILS

Once the overall feel of the environment is in place, it's time to turn the loose gestures into fully realized character sketches. Doing this after the surroundings have been established allows them to interact with the environment in a realistic and tactile way. Try to figure out exactly what the characters are looking at and touching, as well as their overall poses. Remember, a character in motion is engaging for the viewer. The gaze of a character can create action within the image – the viewers will be inclined to follow their line of sight and observe what the character is interacting with.

COLORING CHARACTERS

Use the Lasso tool again to flat-color the characters. At this stage it's important to ensure there is a crystal-clear read of the characters' poses and emotions. Use value and hue contrast to help clarify and separate the characters from their surroundings. This is a balancing act – the characters should be easy to read, but should still feel like they belong in the environment. If they blend in too much, add contrast. If they stand out too much and feel pasted on top of the background, reduce contrast. Use a brush with Color Jitter to add variations to the color of the clothing.

RENDERING TO FINISH

Now all the groundwork is laid out, it's time to shade, light, and render the image. Think about where light wouldn't be able to reach and add shadow in those areas. If a light is shining on an object, add a cast shadow behind it and add highlights to the object. Add wrinkles to clothing, stray hairs that may have fallen loose from braids, and specular highlights to the eyes. This is a great time to pull up references of various materials to help refine the details on elements such as wood, water, clothes, and hair. Once you feel happy with your rendering, you're finished.

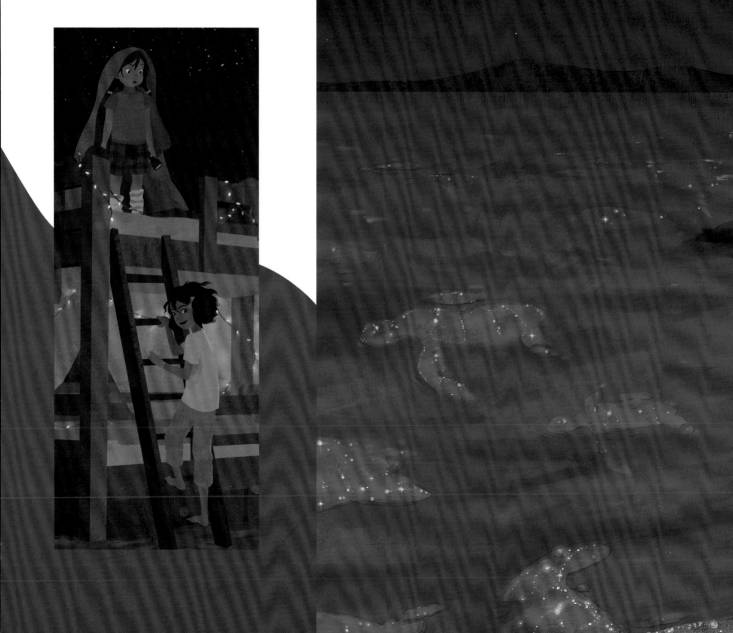

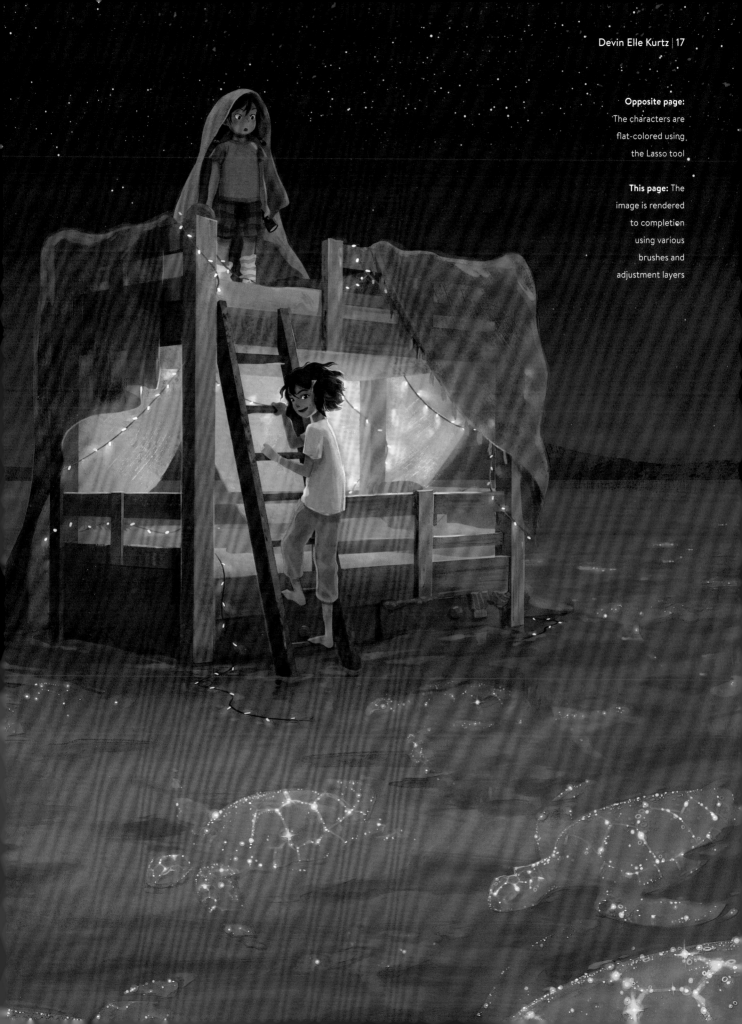

Opposite page:
The characters are
flat-colored using
the Lasso tool

This page: The
image is rendered
to completion
using various
brushes and
adjustment layers

AN EYE FOR AN EYE

JOAKIM RIEDINGER

The eyes are the "windows to the soul," and are therefore one of the most important vehicles for expressing emotion in character design. On these pages, I will show you how to produce characters whose eyes show their intention, mood, and focus in the moment of the image.

DISCOMFORT

When something uncomfortable happens to a person, the body tends to get smaller and takes up less space. The person will most likely avoid eye contact and the eyes will try to find another focal point, creating an impression of unease.

FEAR

A fearful emotion is usually shown through the contraction of the bottom eyelid, in addition to a raise of the inner eyebrows. The shoulders tend to project forward and the head backward to protect the carotid arteries of the neck, which supply blood to the brain.

DISGUST

When a situation or emotion arises that a person is not pleased with, the eyes often close to physically block the unpleasant thing. This is a protection mechanism and a mental barrier.

KEEP YOUR EYES PEELED!

Eyes are a powerful tool to communicate energy levels and a character's overall state of being. Studying eyes and how they contribute to an illustration will elevate your skills when drawing characters and expressing emotions. When you begin drawing, ask yourself the question: "What is the character thinking or saying in that specific moment?" This helps you stick to your initial intention while you progress.

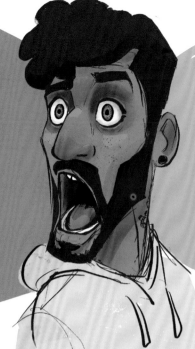

SURPRISE

When eyes are wide open and the eyebrows are up, this is a sign of surprise. The sclera – the white part around the iris – is visible. With eyes wide open, the field of view becomes wider and allows the person to gather more visual information in that moment of wonder or shock.

CONFUSED

Narrowed eyes are often associated with emotions like disgust, a feeling of suspicion, or concentration. As a matter of fact, the squint of the eyes is an action to physically enhance the visual input of the viewer – it is blocking light and sharpening the focus. We do this when we're confused to try to understand better what we're seeing.

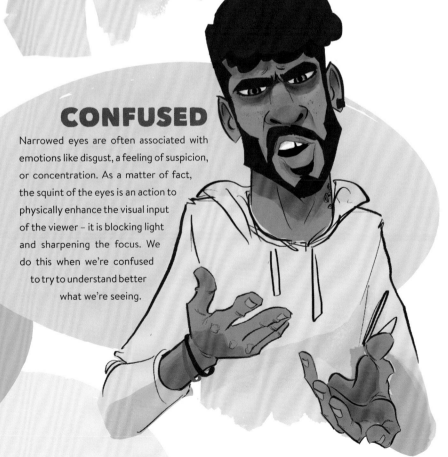

INTRIGUE

When someone is curious or intrigued, they may glance sideways to secretly observe – a small glance is less obvious than a full body turn. The eyes are moving around much more because the neck goes stiff with caution – the eyes compensate for the lack of body movement.

All images © Joakim Riedinger

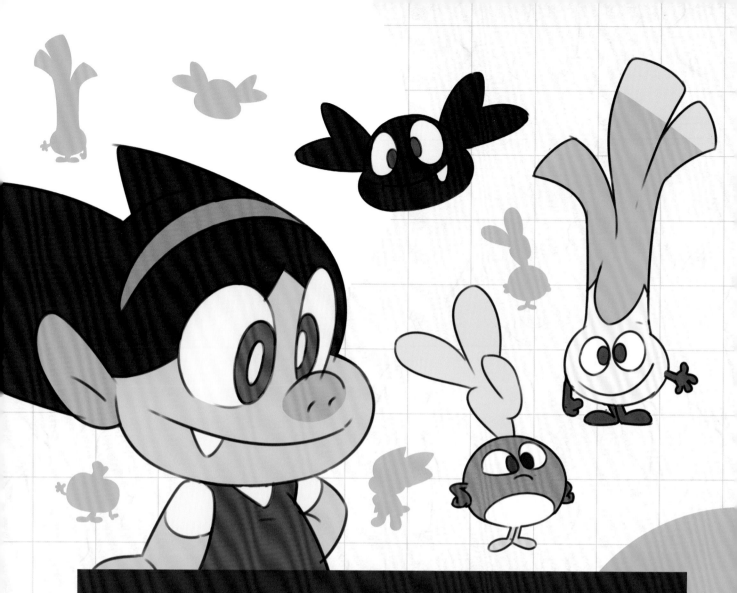

CREATING GAMING CHARACTERS

CHRIS PALAMARA

Videogame characters present designers with unique challenges, compared to more traditional approaches seen in illustration and animation. Videogames as an interactive medium capitalize on the principles and techniques that we're already familiar with from other passive modes of storytelling. They also introduce new opportunities, as well as constraints, for our treatment of character and narrative. Pulling from my personal experience of over ten years in creating characters for games, I have created this tutorial to guide you through the creation process. I've worked with the following premise: "A little vampire who only eats vegetables, trying to solve puzzles to get to them." My primary tool is a Wacom Intuos Pro (M), but my approach emphasizes drawing, so you can follow along using any medium of your choice. Let's go!

BRAINSTORMING

Ease yourself into the creative process by searching the page for ideas with quick, loose sketches, meant to extract an immediate response to the brief. Treat these like visual notes that will reveal potential seeds of ideas to guide your design process. Many of these paths won't be chosen, but the process of eliminating ideas will help in selecting the most successful ones to take forward. These first steps are crucial in establishing the design's trajectory. Allow a measure of freedom, but also look for traits implied by the brief as the first constraint. My sketches reveal a mixed group of vampires that interpret the brief in different ways. It's already apparent which options best serve the brief, leaning toward fun and engaging gameplay, and we will expand upon those options next.

This page (top): A series of rough concept sketches

This page (bottom): Silhouettes offer quick, descriptive insights for macro features like shape and proportion

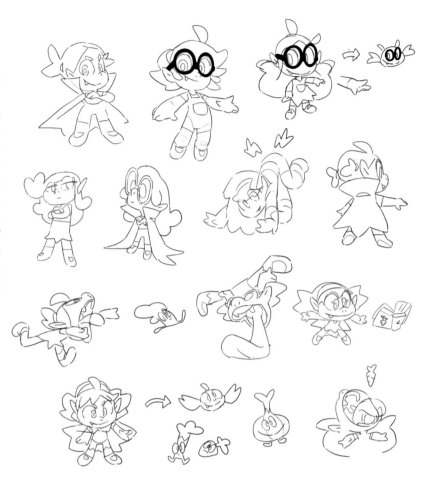

SILHOUETTES

Now dive deeper into developing the design by searching for certain types of proportions and accessories. Here I expand upon some of the most potent ideas I enjoyed from the previous sketches. Without prescribing too many details for now, I set out to capture a cute, squashy appeal to the overall shape. Silhouettes are a great way to generate lots of ideas quickly. Iterating with speed is especially important to game-development pipelines, compared to typical animation workflows, so expressing ideas efficiently is always great practice. You can decide to be looser with your silhouettes than mine, it will depend on what you are looking to extract from them, and at which stage they are implemented.

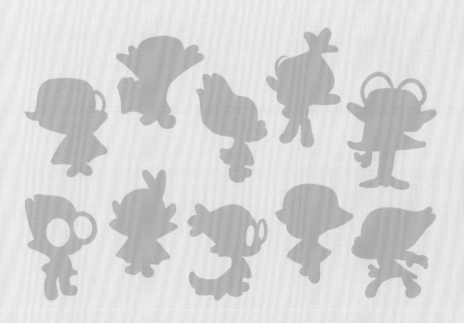

EXPLORATION

I'm already preferring a more ravenous and animalistic appearance for the character, as this creates the most dynamic and engaging gameplay opportunities. This look will also help lead players to the immediate storyline: our vampire is hungry! The design choices should reinforce this detail, so players can instantly recognise this fact. At this stage, it's also important to expand on the ideas that stood out from the previous steps, with increasing specificity. Maybe you liked details such as the bend of an elbow, or the curvature of a cheek? Whatever excites you, now is the time to consolidate those elements into a more focused and controlled concept pass.

MORE EXPLORATION

Through further iterations, I become more decisive about elements I want to keep, versus elements that need to be refined. In the previous steps I established proportions I was happy with, so here I am searching for variations in costume and features while maintaining others. I do this by pushing the boundaries as to what a vampire could look like, mixing potential genres and juxtaposed ideas.

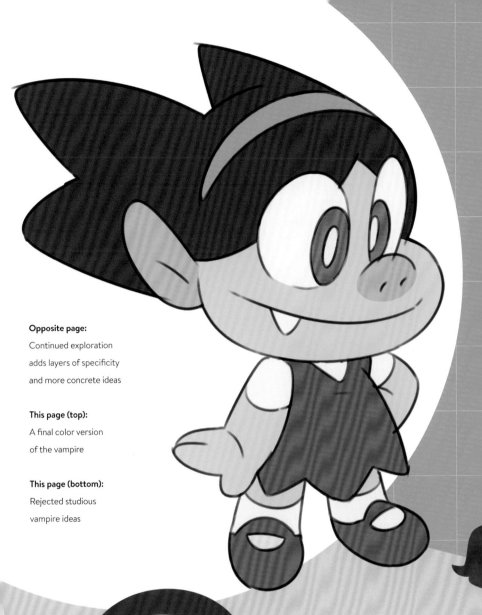

FINALIZING

The option that jumped out most from the previous round makes its way here with a few tweaks. Bat-wing hair makes for a conspicuous vampire motif, next to elements that might otherwise be construed as zombie-ish. Purple is used as a kind of spooky pink to complement her green complexion, keeping the palette dark and playfully haunting. Rounded spikes cameo throughout, in her hair, ears, teeth, dress, and fingers – a repetition that combines "dangerous" and "cute," combined to signal "mischievous." Inspired by previous sketches, she is endowed with a big, wide mouth, good for eating and for storing her outlandishly giant tongue, which we'll have fun visualizing in later steps.

Opposite page:

Continued exploration adds layers of specificity and more concrete ideas

This page (top):

A final color version of the vampire

This page (bottom):

Rejected studious vampire ideas

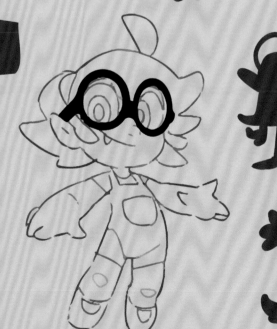

IDEAS TRASH CAN

In the earlier silhouettes I explored a more studious, puzzle-solving vampire, but trashed that idea and chose a more playful character instead. This particular game brief did not outline the style of game play, but as a puzzle game, a platformer style would be best suited. A platformer benefits most from fast-paced movements like jumping and climbing, which my chosen iteration will respond to more effectively.

TURNAROUNDS

Turnarounds are a common resource that designers provide to teams in game development. They are typically used by 3D artists who will translate the characters into 3D. For our purpose during this particular design process, we will use it to generate an objective look at our design to inspect closely, which will inform any adjustments needed.

CALL-OUTS

Call-outs are used to provide a view of certain elements that cannot be seen from the turnarounds. This helps to show any problematic angles or features and exclude them, such as the placement of the bat-shaped hair, the dress, or the shape and size of the hands.

COLOR VARIATIONS

Color helps dictate how a character will be received by players and audiences. It's therefore very important to explore a range of options before settling on final color choices. Our character has a palette divided into hierarchies, making each element easily distinguishable at a glance. For instance, her green arms and purple hair are accentuated by a clear silhouette. This allows the player to quickly identify the character's orientation in space, or if a specific action is being performed. This is especially important in games, because it allows the player to respond and react quickly to changing game conditions. Color usually communicates a specific language in video games, for example red may be reserved for enemies or obstacles. Our vampire is an exception, so taking extra care to select color coding for enemies later will help ensure groups have distinct identities.

Opposite page (top): Producing a turnaround sketch helps us scrutinize the character from multiple angles

Opposite page (bottom): Call-outs reveal details, close-ups, or hard-to-see angles

This page: Testing a range of alternative color options

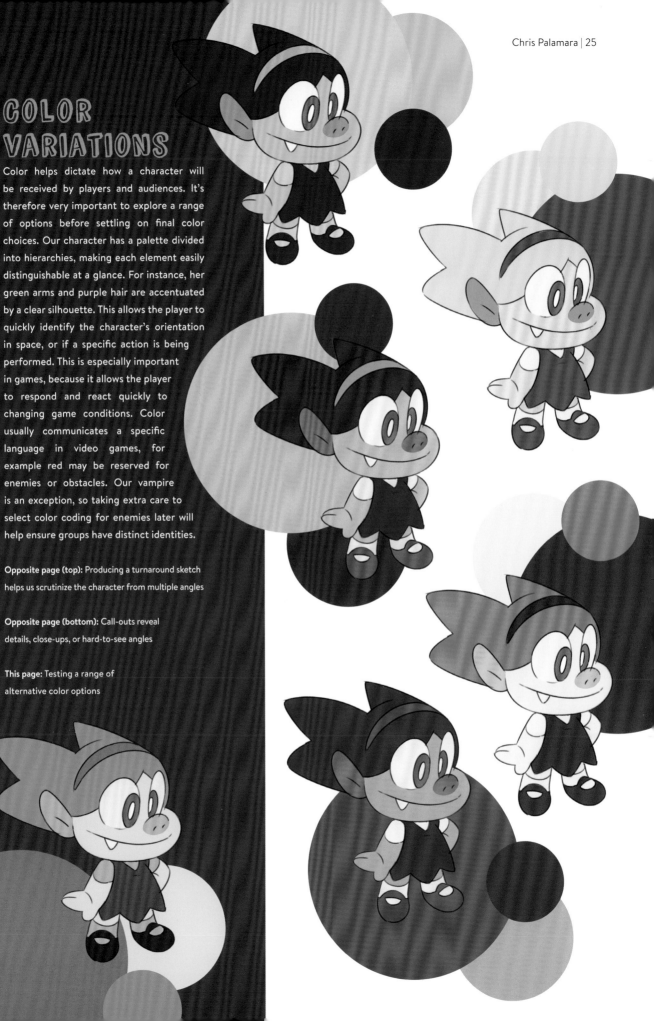

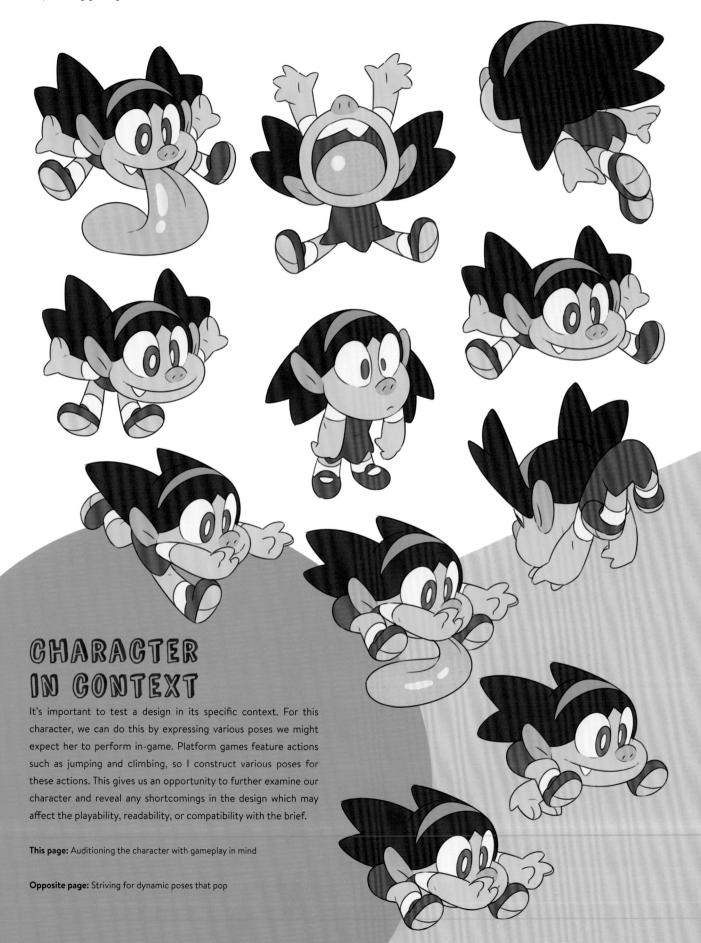

CHARACTER IN CONTEXT

It's important to test a design in its specific context. For this character, we can do this by expressing various poses we might expect her to perform in-game. Platform games feature actions such as jumping and climbing, so I construct various poses for these actions. This gives us an opportunity to further examine our character and reveal any shortcomings in the design which may affect the playability, readability, or compatibility with the brief.

This page: Auditioning the character with gameplay in mind

Opposite page: Striving for dynamic poses that pop

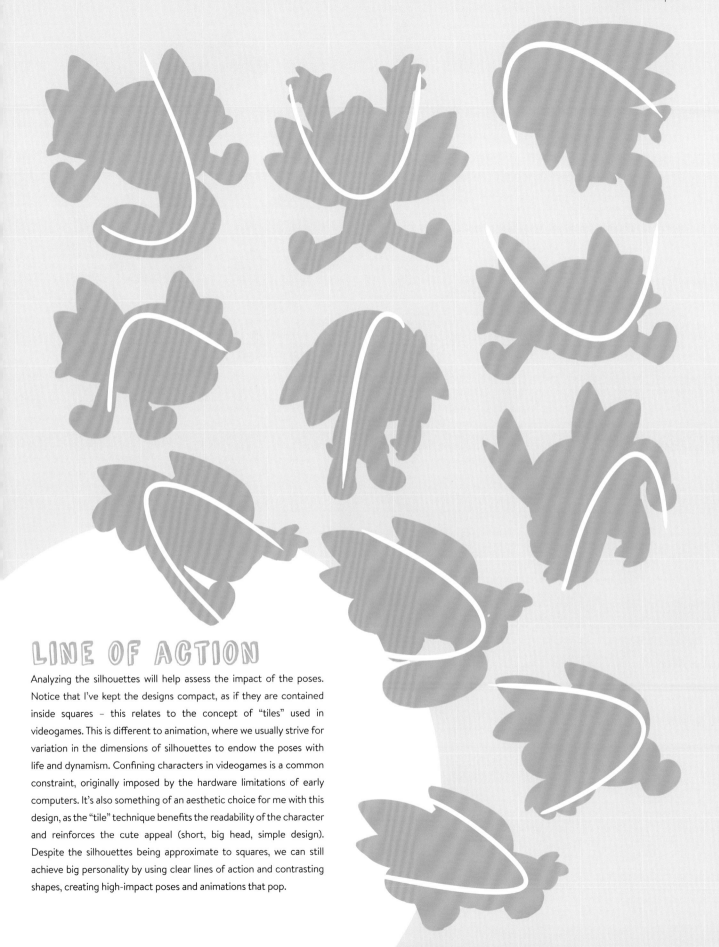

LINE OF ACTION

Analyzing the silhouettes will help assess the impact of the poses. Notice that I've kept the designs compact, as if they are contained inside squares – this relates to the concept of "tiles" used in videogames. This is different to animation, where we usually strive for variation in the dimensions of silhouettes to endow the poses with life and dynamism. Confining characters in videogames is a common constraint, originally imposed by the hardware limitations of early computers. It's also something of an aesthetic choice for me with this design, as the "tile" technique benefits the readability of the character and reinforces the cute appeal (short, big head, simple design). Despite the silhouettes being approximate to squares, we can still achieve big personality by using clear lines of action and contrasting shapes, creating high-impact poses and animations that pop.

BAT GAME MODE

To help our vampire traverse levels and to add more opportunities for platforming in the game, I add a "bat transformation mode," which is consistent with the little vampire theme. We can maintain the identity of our character by keeping some of her visual anchors while she is in bat mode. This is done by targeting the most iconic elements of the design and making them more compact for the smaller bat form. The winged-style hair makes this relatively easy, as they translate into real wings and create a recognizable, seamless transition.

NPC RESEARCH

Let's explore some companion characters for the vampire to interact with. One of my initial reactions to the brief was to have vegetables as NPCs (non-playable characters), to populate the world and flee from the hungry vampire. This pass of exploratory sketches is an expansion of some earlier ideas set out in the very first exploration in step one, so I already have a head start in defining some visual traits. I make sure to maintain the same look and feel across the vegetables stylistically, and adding color at this stage gives a good sense of how they will interact visually with the main character.

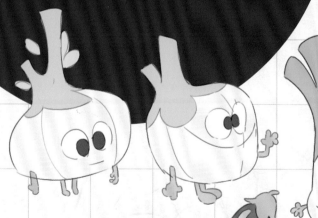

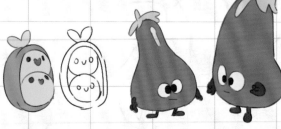

This page (top):
Vampires are known for turning into bats – so ours is no exception

This page (bottom):
Concept sketches for the vegetable NPCs within the game

Opposite page (top):
Turnarounds of the NPCs

Opposite page (bottom):
Prop sketches that act as an extension of the character

NPC TURNAROUNDS

It is important to create turnarounds of the NPCs as well as the main character, as they help define how the characters can be integrated into the game world. These will be handed off to the 3D artists and will inform the game art assets we'll see in the game.

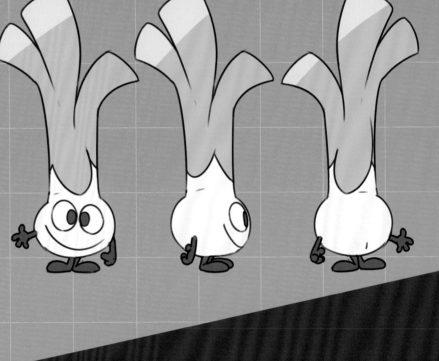

How to cook vegetables!

No place to hide!

spooky!

PROPS AND ACCESSORIES

Props are a crucial part of a character design, as they help communicate plot and personality. Props in games need to be practical and should match, or contrast, with the character. At this stage I sketch out some props I imagine the vampire character might use.

THE ENTIRE CAST

Finally, we put all the characters together to check how well the cast fit. This helps ensure harmony and vibration between the characters in terms of visual keys, such as color and shape. Silhouettes are crucial as they help the players immediately identify the characters. Examining the silhouettes in a line-up will help reveal if some shapes look too similar and any adjustments are needed. Ensure you are checking this as you continue to expand the cast with more characters.

These pages:
Once we've ensured the cast works well together as well as separately, we're done!

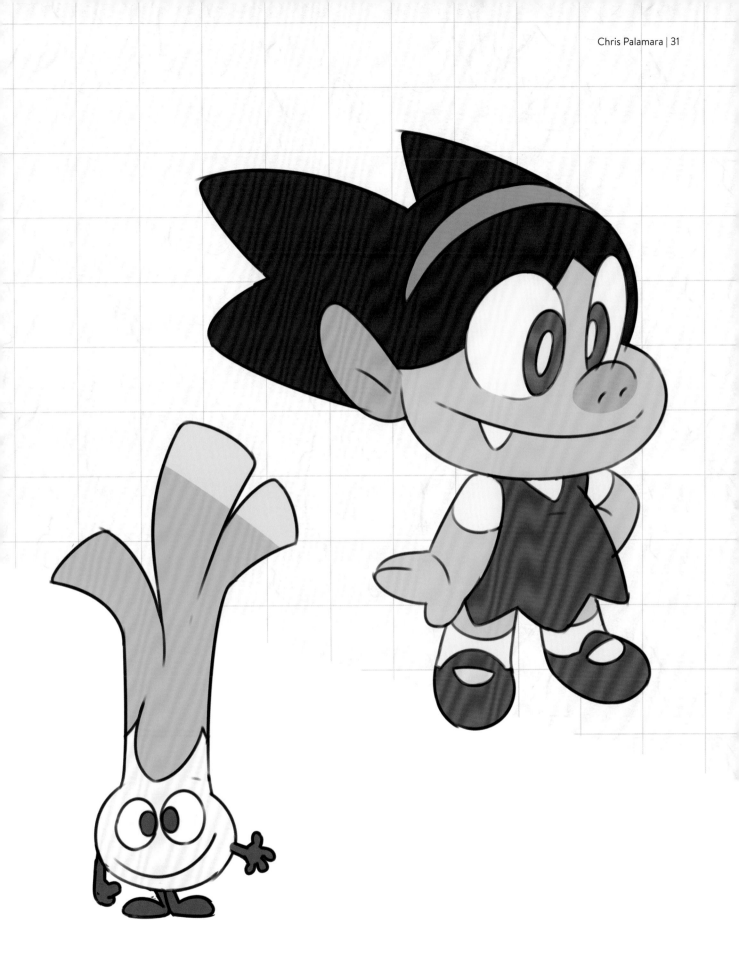

ARTIST CATCH-UP:

JAMES A. CASTILLO

Art director and character designer James A. Castillo chats
to us about his personal projects, dealing with a crazy 2020,
and his hopes for the future of the animation industry.

Hi James, it's great to talk to you! For our readers who might not be familiar with your work, could you give us a brief introduction?

Hey guys – it has been a while. I'm very flattered that you wanted to have a catch up and see what I've been up to since we last spoke. For those who have no clue who I am, which I'm sure is a fair few of you, I'm James from Spain and I love spicy food. I'm a character designer and visual-development artist turned director. I've worked on commercials, games, TV shows, films, and VR projects – all sorts really. Luckily for me, animation keeps expanding into new and unexplored territories, so there is always something interesting to get involved in. I'm currently on the last stretch of producing a VR production with No Ghost Studio in London.

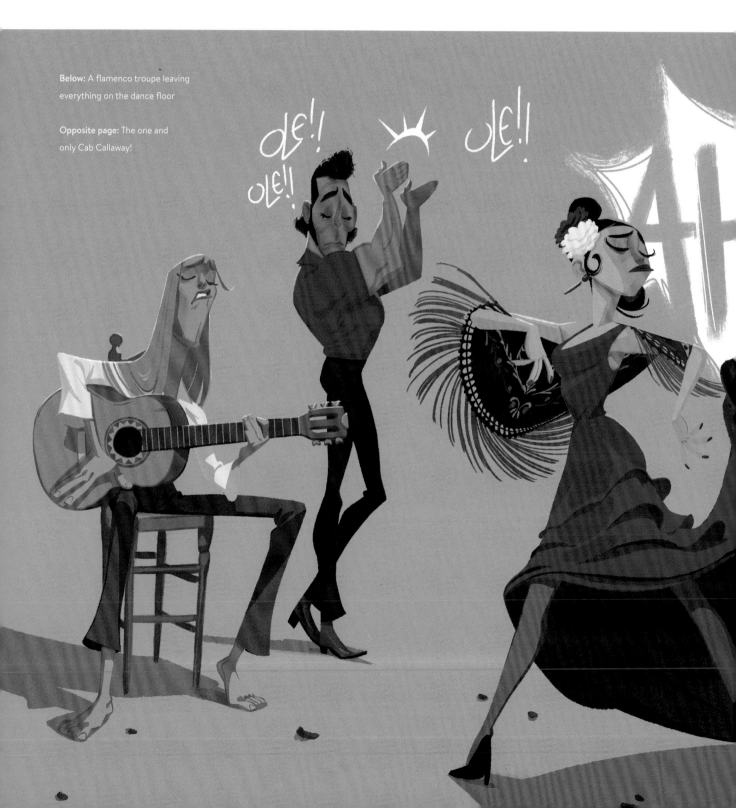

Below: A flamenco troupe leaving everything on the dance floor

Opposite page: The one and only Cab Callaway!

"ANIMATION KEEPS EXPANDING INTO NEW AND UNEXPLORED TERRITORIES"

We interviewed you back in 2018 for issue 6, and it feels like the world has already changed quite a bit since then. What kinds of projects have you been working on since we last spoke?

2018 seems like ages ago, doesn't it? Probably the biggest difference since we last spoke is that the *Madrid Noir* project I had just finished has now been made into a fully developed VR experience. It has been a huge undertaking, with a team of over 40 people across three countries working on it for over a year. The other highlight has been working as a character designer on *Mitchels vs the Machines* with the lovely guys at Sony Animation, which I can't wait for everyone to see. Other than that, I've been working on some other design and illustrations jobs here and there, but getting *Madrid Noir* off the ground has taken most of my energy these past couple of years.

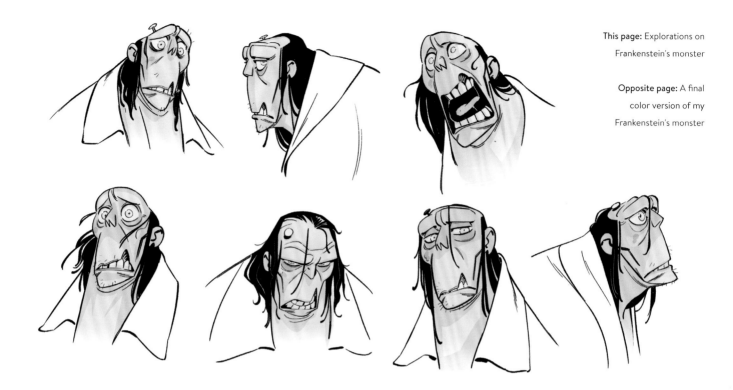

In your last interview, you spoke about being inspired by the world around you – is that still your main source of inspiration?

Recently I've found myself increasingly being inspired by classic literature – which is probably noticeable in my more recent works. One revolutionary aspect that has entered my life (as I'm not as tuned in with the kids these days as I thought I was) has been audio books. Having the ability to "read" books while working on other tasks is great and it's expanded my knowledge of literature. I've listened to everything from *Dune* to *Frankenstein*, and *Don Quixote* to *Alice in Wonderland*. I'm fascinated by exploring why these stories have become such staples of popular culture, as well as seeing how they've been portrayed and interpreted by media over the years. I find it interesting to go back and read the original source of a story that has been retold many times, especially within the nostalgia-driven market we see today.

Have you seen much of a change within the animation business over the last couple of years?

I could talk about this for hours. I have seen a lot of change within the industry, mainly in the way that it is produced and distributed. Even before the pandemic, streaming services were dominating media and changing the norm. The pandemic has cleared any doubts in anyone's mind about their legitimacy and place within the industry. I think we are moving toward a landscape that is more specific and curated. Shows like *Primal* or *Tales of Arcadia* are great examples of how strong creative projects can have laser-focused audiences and be successful. Instead of green-lighting projects with broad appeal, studios are becoming more comfortable with creating niche content, knowing it will find an audience. New players in the industry are making the landscape more competitive, which forces the larger companies to take more risks and look for interesting stories to stand out from the crowd.

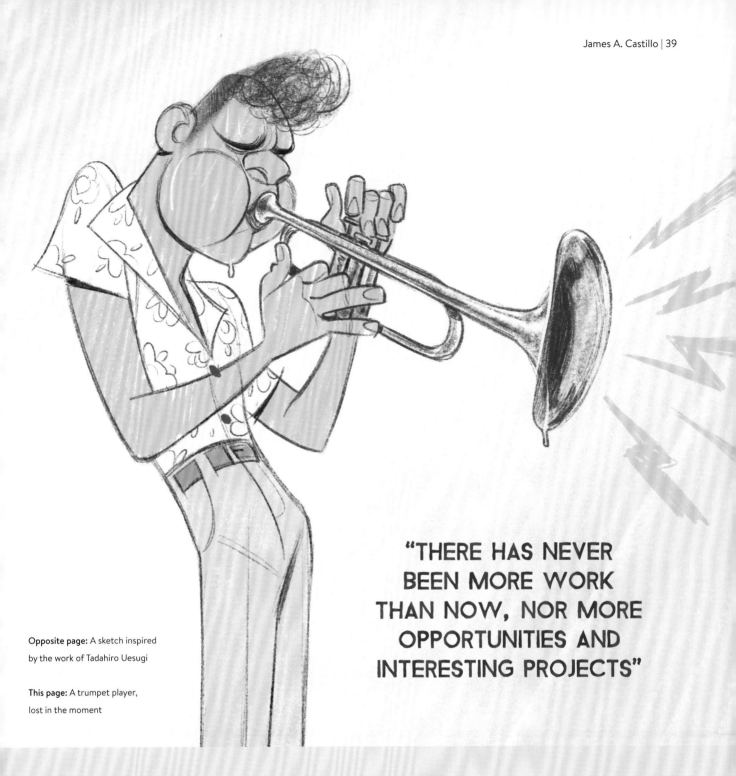

Opposite page: A sketch inspired by the work of Tadahiro Uesugi

This page: A trumpet player, lost in the moment

"THERE HAS NEVER BEEN MORE WORK THAN NOW, NOR MORE OPPORTUNITIES AND INTERESTING PROJECTS"

With the new normal created by the pandemic, would you consider animation a worthwhile industry to be going into at the moment?

Absolutely – there has never been more work than now, nor more opportunities and interesting projects. Animation won't go anywhere, as there are always new companies coming into the field, as well as established companies branching out into all sorts of new ventures, such as interactive narratives and virtual reality. Fortunately for us, animation is a process that operates well over long distances. The industry has always required long-distance relationships between studios across different countries. Since the 60s, most projects have been created by teams from around the world. For example, the *Batman* animated series was produced in Korea, and Disney have satellite studios in Paris – it's an industry standard to operate worldwide. So, no, I don't think the "new normal" is going to discourage newcomers or prevent the animation industry from growing – the reality is quite the opposite.

So, although thankfully the industry hasn't suffered during the pandemic, has your role as an art director changed?

The role of art directing, or any directing for that matter, is defined by two very distinct aspects – the creative one and the managerial one. With the creative aspect, you talk with the director, gather references, organize ideas, explore, and create style guides – all tasks which have stayed relatively intact. The managerial aspect is a bit more complicated now. As an art director, you have to manage a team. This isn't just assigning tasks and setting goals, but understanding people's strengths and weaknesses, and ensuring they stay motivated and invested in the project. This becomes increasingly difficult when you have spent half the year in your room and may not have met some of the people working on the project. This is a big contrast to when you share a space, where you can often see what the modellers, animators, and producers are doing. You can literally hear the cogs of the machine moving around you, so everyone tends to be motivated and keep at it. It also helps give everyone a clear understanding of the progress of a project at every step.

So, how have you tried to keep your team motivated from afar?

It has been a challenge, since we had to adapt as the restrictions changed throughout the year so there was a lot of improvisation. Something that worked really well at the beginning was to have weekly virtual meetings where members of different departments would present what they had been working on, which allowed the rest of the team to see how projects were moving forward. We also tried to involve people from different areas to help us find creative solutions to some problems, such as user experience, or design. Another thing we did was arrange the occasional pub quiz via video-conferencing, which helped keep the spirits up when we couldn't socialize.

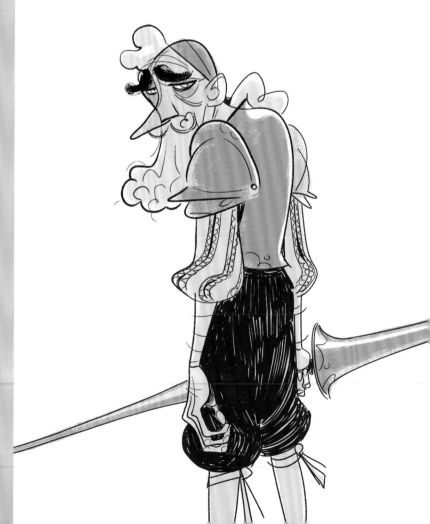

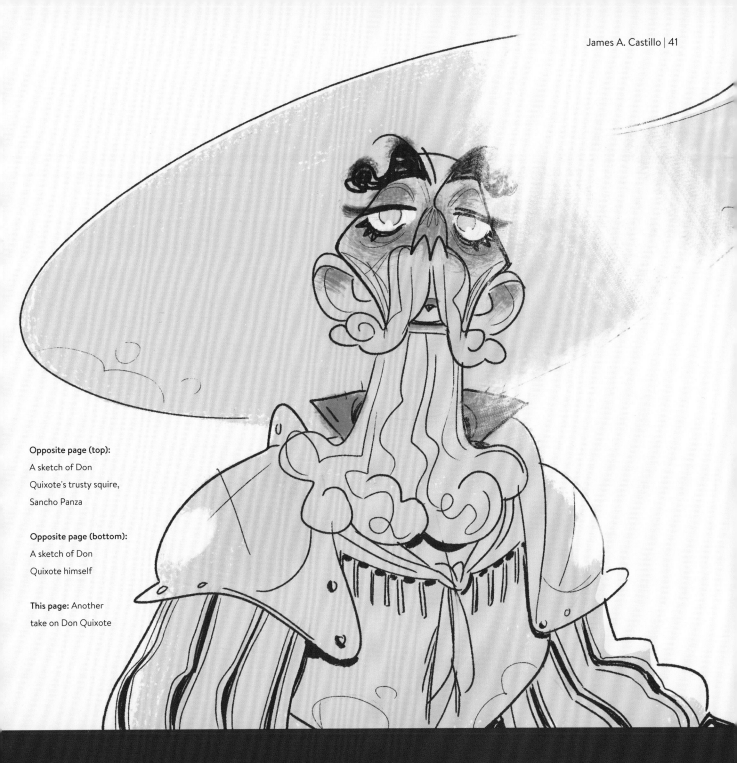

Opposite page (top):
A sketch of Don
Quixote's trusty squire,
Sancho Panza

Opposite page (bottom):
A sketch of Don
Quixote himself

This page: Another
take on Don Quixote

You are very engaged with art on social media. Do you have any tips for staying motivated to create and share online?

That's very kind of you to say, but I know I could do better! Social media can be a double-edged sword, it is a fantastic tool, but it can be dangerous if you abuse it. One way I've found to help is to remind myself, and as corny as it sounds, that my "artistic growth" is private. I find that the more I post, the more I become aware of what people like and dislike about my work, which can make you hyper aware of everything you're creating. As artists, we are always learning, and that means making mistakes, trying new things, and exploring new subjects. This is hard to do when you have the pressure of keeping your social media constantly active. Often you can become stagnant if you keep making content that only appeals to your audience on social media. But don't be mistaken – I love engaging with social media, it can help enormously with your career. I have learned over the years that the more personal you make your engagement with your followers, the more you will be able to share when you explore and grow.

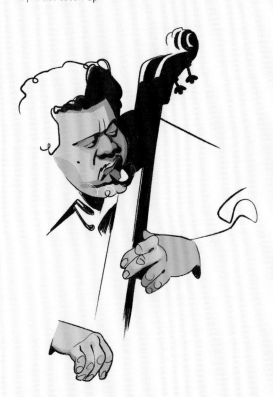

Do you have any advice for artists and designers who may feel a little disheartened due to the current global situation?

Things will have slowed down and some projects may have stalled. But to be honest, this is a very resilient industry as a whole. We've seen teams come together on all fronts, because we all love this industry and want to create content that is worthwhile. While 2020 felt like a do-over year for many new artists, the industry is learning how to become more flexible and that means better opportunities in the future for a wider range of talent. It's become unnecessary to live in the top cities in the world in order to become part of a project, as we've all become remote workers, which means different types of people can join a team and make an impact.

You previously spoke about the importance of attending events, festivals, and workshops. Do you think there are good online alternatives now?

As exciting as new ventures are, such as View, Annecy, and LightBox, there is no precedent for these kinds of events. It's an amazing adaptation and I'm sure there will be more online content featured in festivals going forward, but I don't see it as an adequate replacement for the in-person experience. It ultimately boils down to human interaction. We work in a pretty insular industry; unless you live in LA, chances are the animation community in your city is pretty small. So having the opportunity to travel to another country to mingle and network with other people who work in the industry you love is vital for a healthy and successful career. These are places where friendships can be made and ideas are discussed and debated. On the other hand, being able to watch previews of new projects and talks from home is very convenient for those who can't afford to travel. In this case, all the effort the creators of festivals have put into transitioning their events online should remain intact in the future. The more bridges we can create to help connect people will only benefit the industry in the future.

Opposite page (left):

A sketch of Charles Mingus

Opposite page (right):

A sketch of Nina Simone

This page: A sketch
of Jimi Hendrix

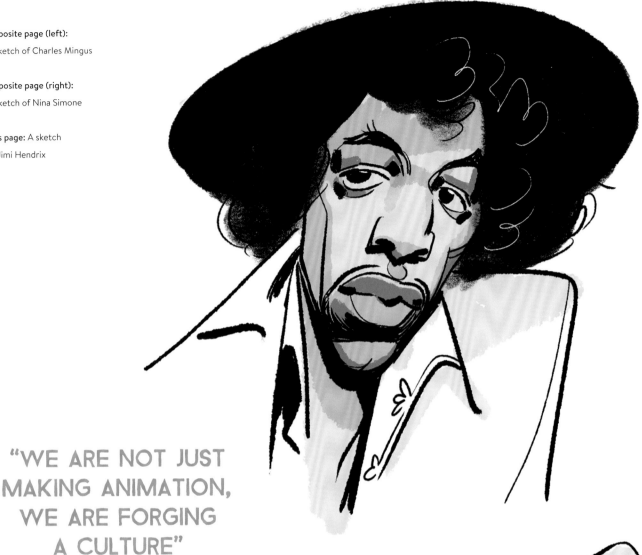

"WE ARE NOT JUST MAKING ANIMATION, WE ARE FORGING A CULTURE"

What do you love most about the animation industry, and what are your hopes for the future?

Something I want to touch on is how important diversity is. I am very proud to be working within an industry that is leaps and bound ahead of others in terms of representation. This community has so overwhelmingly embraced LGBTQ+ creators. It allows people's voices to be heard about the behavior and attitudes that can operate within the workplace, and that has led to big changes to help address issues such as systemic racism. There is no future for this industry without new voices, and we need studios to champion new and upcoming artists, teach them, and give them a platform to make new and exciting content. If you are just starting out in your career, I encourage you to think beyond finding a job, and instead think about what you want the industry to be like in the future, and make the first move. After all, we are not just making animation, we are forging a culture.

HOW I STYLIZE
NÚRIA TAMARIT

In my illustrations, I try to highlight only the most important and characteristic elements of the character or scene I want to represent. To achieve this, I use the simplification and synthesis of bodies and forms, as well as of ideas, with the intention of drawing only the essential aspects that respond to the idea of what I want to express. I always start with a small pencil sketch, then I add the line work (also with a pencil), and finally I add color to the artwork digitally. Here are a few different illustrations along with explanations of my stylization techniques.

CONSIDER THE SHAPES
OF THE CHARACTER

DISPROPORTION IS A
VERY USEFUL RESOURCE
WHEN STYLIZING
ILLUSTRATIONS

THINGS DON'T
HAVE TO BE
REALISTIC

REPEAT SHAPES
TO FIND HARMONY

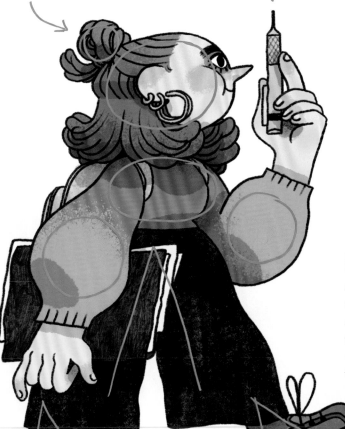

KEEP IT SIMPLE

Always try to summarize the essential concept of what you want to draw. What elements should be included for your drawing to say what you want it to say? For example, in this image I wanted to include a pencil and to give the character's body a sense of movement. By focusing on these aspects, they become the main features of the character.

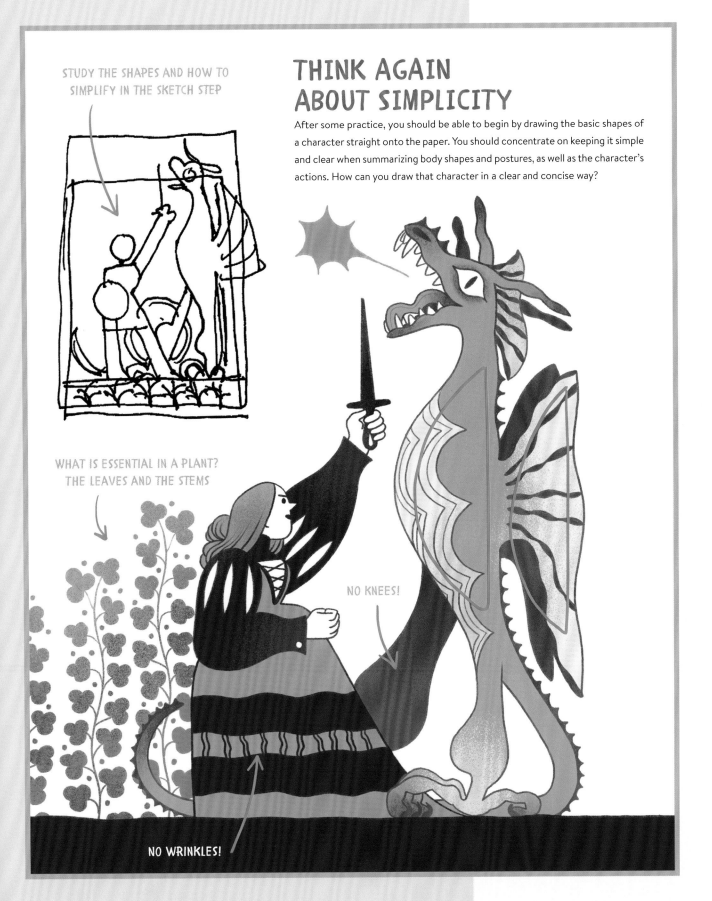

STUDY THE SHAPES AND HOW TO SIMPLIFY IN THE SKETCH STEP

THINK AGAIN ABOUT SIMPLICITY

After some practice, you should be able to begin by drawing the basic shapes of a character straight onto the paper. You should concentrate on keeping it simple and clear when summarizing body shapes and postures, as well as the character's actions. How can you draw that character in a clear and concise way?

WHAT IS ESSENTIAL IN A PLANT? THE LEAVES AND THE STEMS

NO KNEES!

NO WRINKLES!

COMPOSITION LINES

It's important to think about how a character reads visually. To do this, think about where to place the important elements and how to guide the eye throughout the drawing. The more simplified the elements, the better they will read.

MORE DETAILED
AREAS AT THE TOP
OF THE IMAGE

THE SIMPLIFIED
AREAS HELP
BRING BALANCE
TO THE IMAGE

THE EYE IS DRAWN
DOWNWARDS FROM
THE HAT TO THE FEET

GO A LITTLE FURTHER

Once you can draw freely, you push things a little further. To achieve greater stylization, try using geometric elements, such as circles and rectangles, and more abstract compositional lines, such as diagonals.

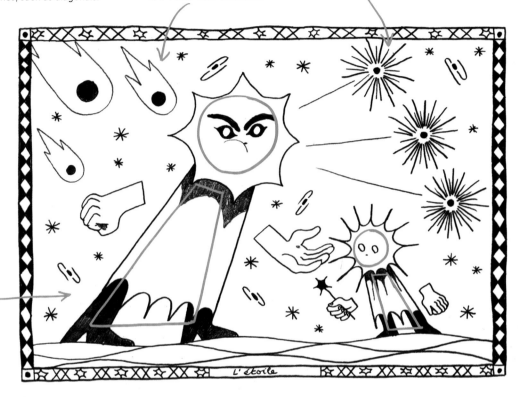

WHAT MAKES A COMET A COMET? BY SIMPLIFYING THIS SHAPE YOU CAN CAPTURE THE ESSENCE

THE CHARACTER SHAPES REFLECT THOSE USED WITHIN THE STARS AND COMETS IN THE IMAGE

A SIMPLE TRIANGLE AND CIRCLE MAKE FOR A STRONG, SIMPLIFIED CHARACTER

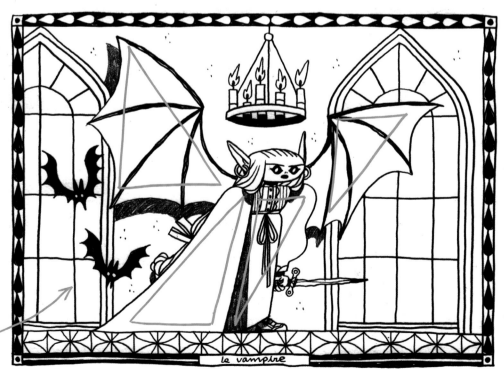

IMAGINING JUST THE SHADOW OF AN ANIMAL WILL HELP YOU TO SIMPLIFY ITS SHAPE

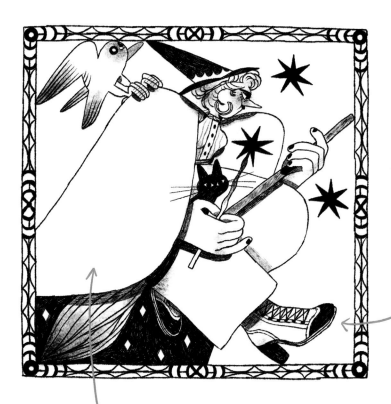

ADDING DETAILS

Be careful when adding details. Keep in mind that too much detail can make the illustration overloaded and cause confusion. I like to balance an image by combining detailed areas with simpler areas, so the drawing can breathe. It's important to know when to stop! Start on the most important areas of the character, regularly stopping to review the overall image, and then decide if more detail is needed.

A DETAILED SHOE TO DRAW THE VIEWER'S EYE

SOMETIMES IT'S BETTER TO LEAVE THE AREA EMPTIER THAN TO DRAW TOO MANY DETAILS

A PLAINER AREA TO KEEP THE FOCUS ON THE WITCH HERSELF

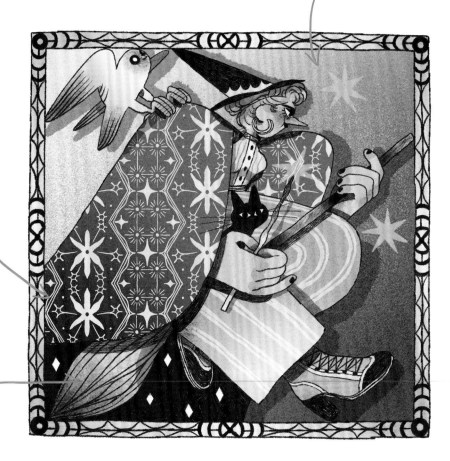

YOU CAN ALWAYS MAKE A SIMPLIFIED PATTERN TO FILL A SPACE

LIMITED COLOR PALETTES HELP KEEP AN IMAGE STRONG AND SIMPLE

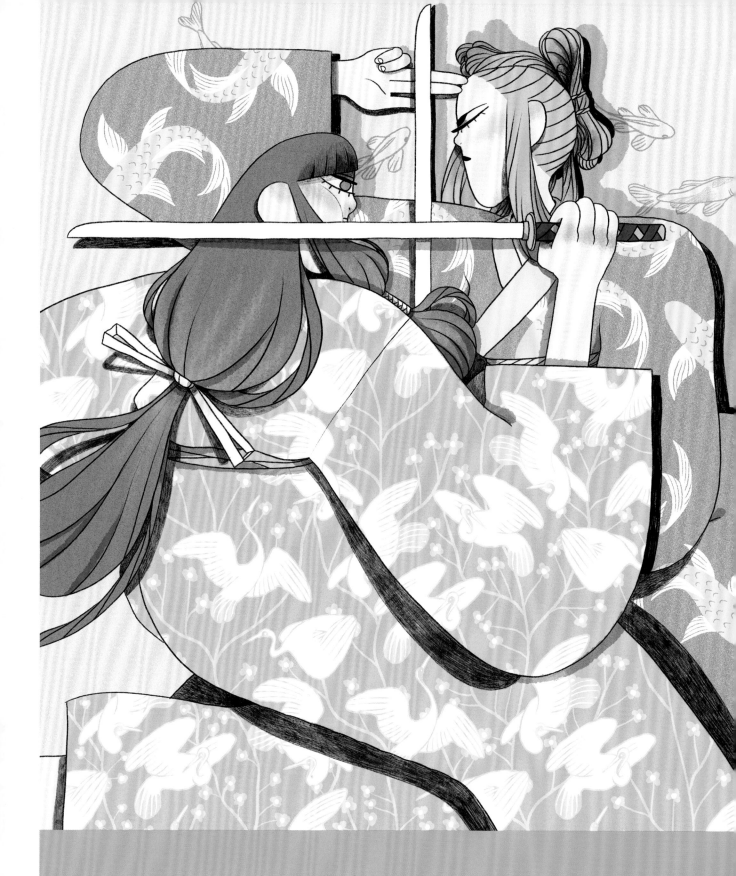

MAKE YOUR OWN RULES

Now that I've shown how I simplify and stylize my designs, you can take this as inspiration to make up your own rules. Try simplifying different shapes and objects, combine your various skills, and keep on drawing. That's the way to build a good base for an authentic and personal style. Most importantly – enjoy yourself!

HOW TO KEEP A SKETCHBOOK
MADISON HARPER

Your sketchbook is an important tool to help with storytelling and developing characters. You'll want your characters to express themselves through facial expressions and body language; elements that are best explored and practiced in a sketchbook. The beauty of a sketchbook is that it's like a diary. You can use it to explore ideas when your mind wanders – ideas that you can then develop further into finished characters. On the next few pages, you'll find a way to center in on character designs suited to a comic or narrative illustration, and learn how to keep your characters expressive and recognizable throughout the story by using your sketchbook.

THE START OF A NEW PAGE

Beginning a fresh sketchbook is always daunting, but once you start, even if you're not happy with the first few pages, it makes a huge difference. One benefit of using a sketchbook is that you can keep it hidden for as long as you like, which helps free you from the expectation that every page needs to be perfect. A great way to start is to dig up some old photos, or images that inspire you, and draw what you see. These mindless doodling pages can help inspire projects and they can be amazing to look back on once you have put more thought and development into them.

This page: The beginning of a new sketchbook with loose pencil sketches, made using a 6B pencil

BE EXPRESSIVE AND EMOTIONAL

This is a great exercise to incorporate into your warm-up routine, or just for general practice! Instead of being distracted by multiple features, work on simply conveying emotion through the expression on the face itself. Start with a circle and find some old photos (family photos work great for this), then translate the expressions you see right into the circles on the page. Try to keep your eyes on the reference more than the drawing. Expressions are one of the greatest elements in character design, as they can convey much of the story with just one look.

This page: Sketchbook page with a simple exercise to practice expressions

Opposite page (top): An example of a page devoted to practicing expressions further, incorporating some shading into it

Opposite page (bottom): Collection of life-drawing sketches from a warm day at the beach

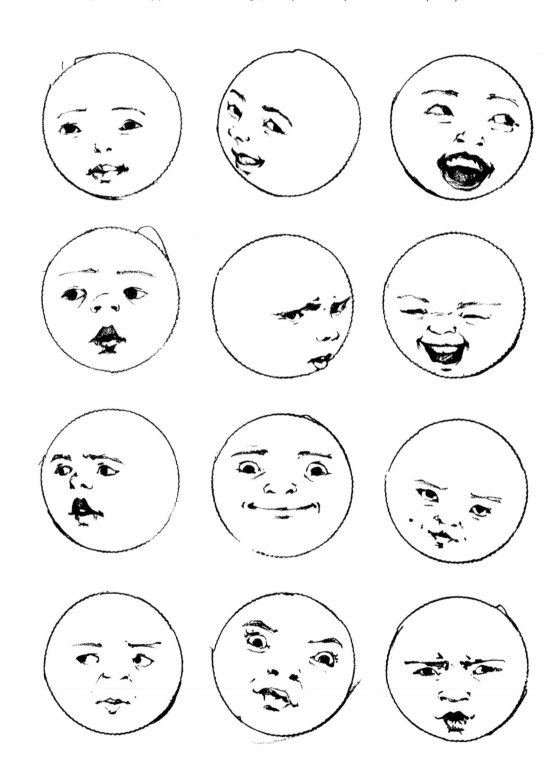

PRACTiCE FOR YOURSELF

Once you have started to master drawing simple expressions, try incorporating full head and shoulders. Devoting a page or two to this will help when starting to translate your character over to an illustration or panels for a comic. With this warm-up you can play around with hairstyles and accessories and see how they affect the overall feel of a character. As always, draw what makes you happy, as this is the exploratory stage – if you experiment and let go of any concerns, it will help when narrowing in on a design later.

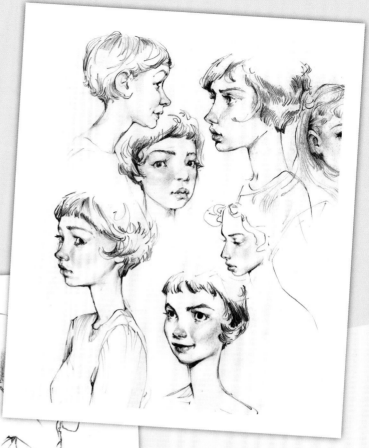

DRAW FROM LiFE

Using photo references is probably one of the more convenient ways to practice drawing, and it's much better than no practice at all. But drawing from real-life will always be a step up and more beneficial to your practice. Life-drawing forces you to translate a three-dimensional object onto a two-dimensional surface. The drawings become more expressive when you're working with moving figures, as you try to capture the movement on the page. It's a great way to work on poses and body language, which are as important as facial expressions in character design. Practicing these quick life-drawing sketches can add life to your characters.

PHONE A FRIEND

Once you start to use your sketchbook to plan a concept for an illustration or comic, you might need a specific pose to fit your narrative. As mentioned before, body language can tell you a lot about your character. Here's where it can be useful to find someone you know who is willing to pose for you. It's always a bonus if they're a similar age to the character you're creating as well.

This page (top): Character drawing taken from a reference photo of a young family friend

This page (below): A sketch started with a blue-lead pencil

Opposite page: A sketch trying out different techniques in the character's hair and using sharper shapes

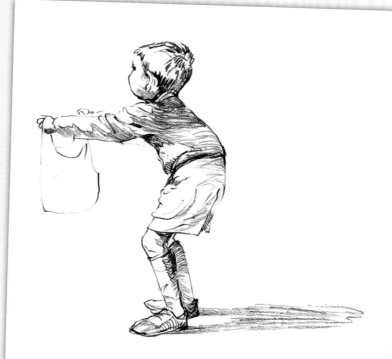

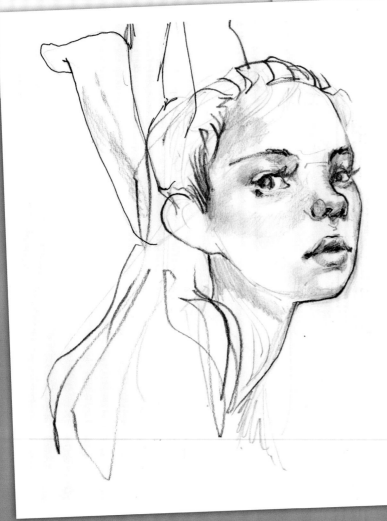

BLUE PENCIL SKETCHES

If you are a little too nervous about making a mistake in your sketchbook, or start a sketch without a solid idea, you can always try using a blue-lead pencil. They are light enough that you can make adjustments as you draw without erasing, and it fades out once you use a darker pencil over it. This is a good way to learn to have more control over your drawings, while also drawing freely in your sketchbook.

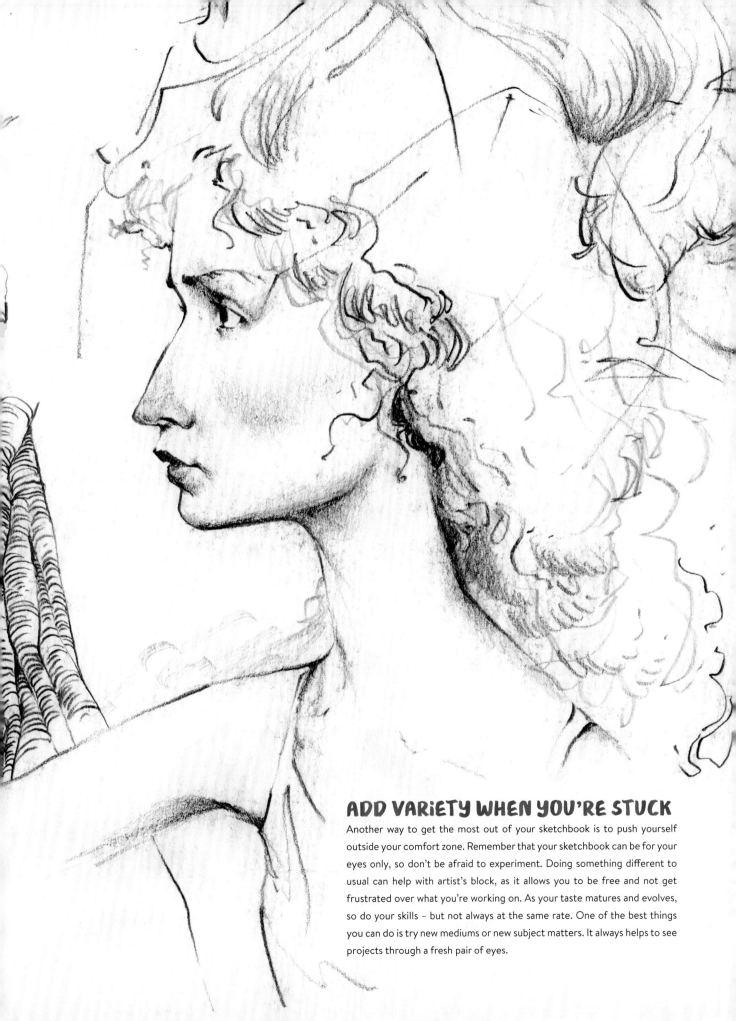

ADD VARIETY WHEN YOU'RE STUCK

Another way to get the most out of your sketchbook is to push yourself outside your comfort zone. Remember that your sketchbook can be for your eyes only, so don't be afraid to experiment. Doing something different to usual can help with artist's block, as it allows you to be free and not get frustrated over what you're working on. As your taste matures and evolves, so do your skills – but not always at the same rate. One of the best things you can do is try new mediums or new subject matters. It always helps to see projects through a fresh pair of eyes.

START TO NARROW iT DOWN

For a particular comic I'm working on, I want to include five different child characters. This is where I can look back through my sketchbooks to see if any old sketches or doodles catch my eye. You can use your rough sketches and build your characters from there. Here, I found a page where I had drawn some children right around the age I need for my characters, so I pull inspiration from these as I move forward with the character design.

This page:
A sketchbook page further along in the development process

Opposite page:
A collection of sketches where I begin to think about the characters' personalities

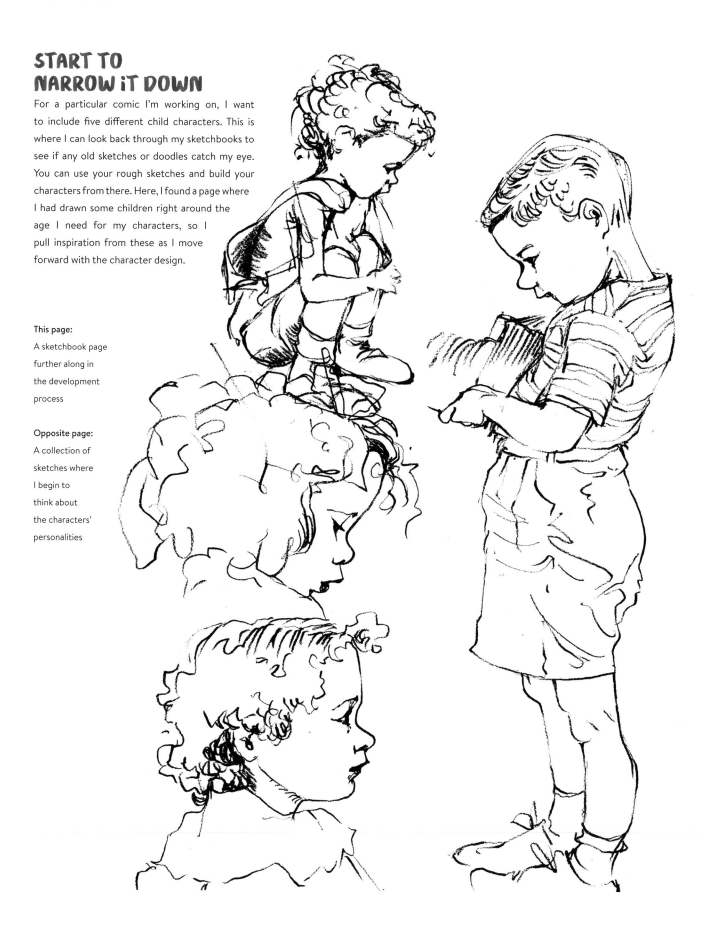

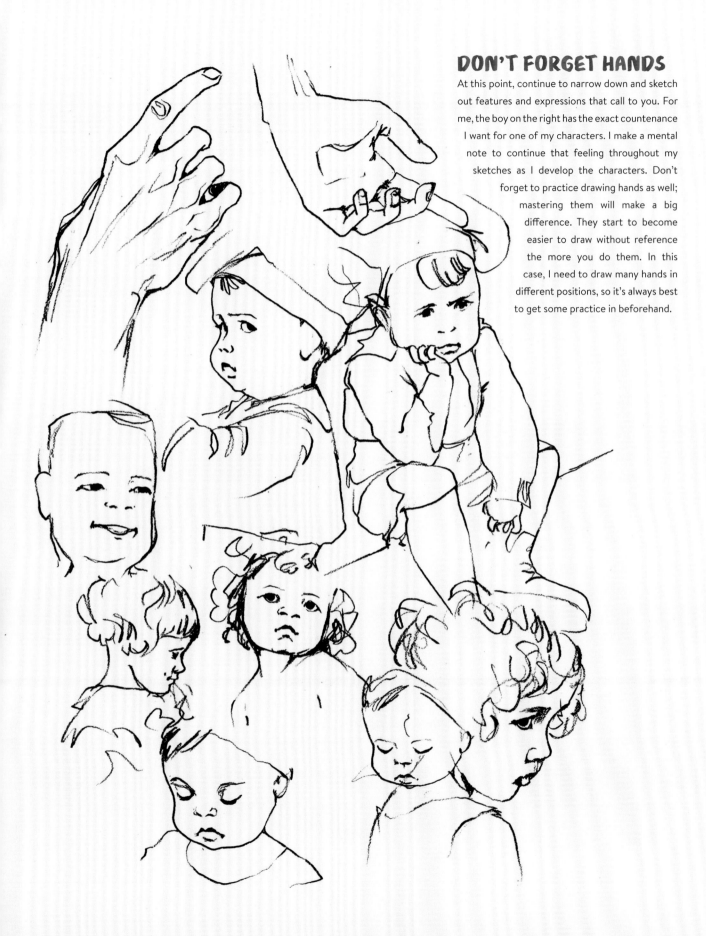

DON'T FORGET HANDS

At this point, continue to narrow down and sketch out features and expressions that call to you. For me, the boy on the right has the exact countenance I want for one of my characters. I make a mental note to continue that feeling throughout my sketches as I develop the characters. Don't forget to practice drawing hands as well; mastering them will make a big difference. They start to become easier to draw without reference the more you do them. In this case, I need to draw many hands in different positions, so it's always best to get some practice in beforehand.

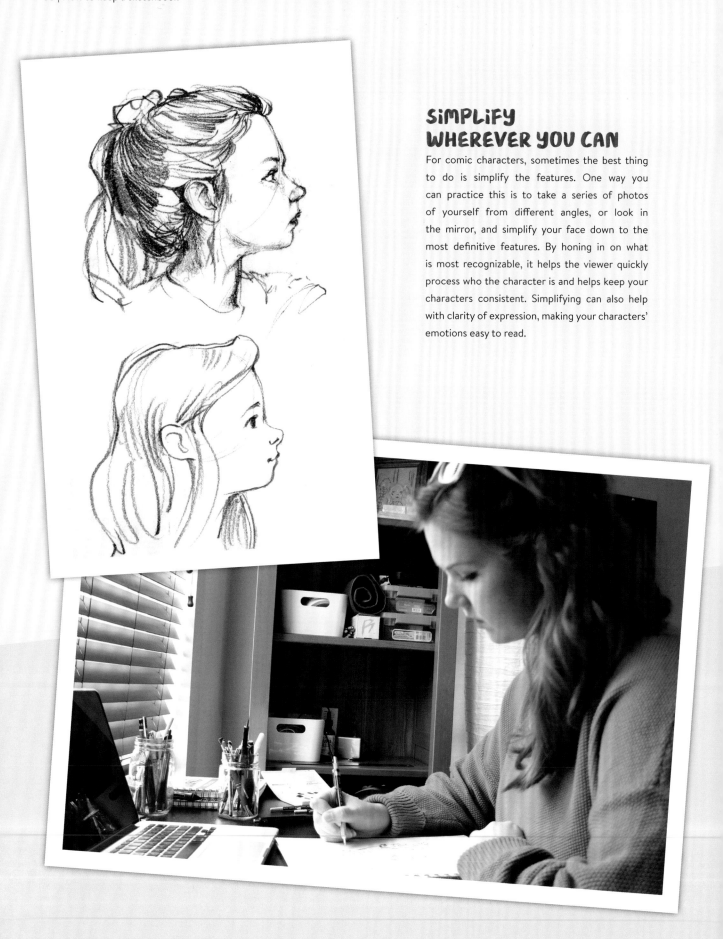

SIMPLIFY WHEREVER YOU CAN

For comic characters, sometimes the best thing to do is simplify the features. One way you can practice this is to take a series of photos of yourself from different angles, or look in the mirror, and simplify your face down to the most definitive features. By honing in on what is most recognizable, it helps the viewer quickly process who the character is and helps keep your characters consistent. Simplifying can also help with clarity of expression, making your characters' emotions easy to read.

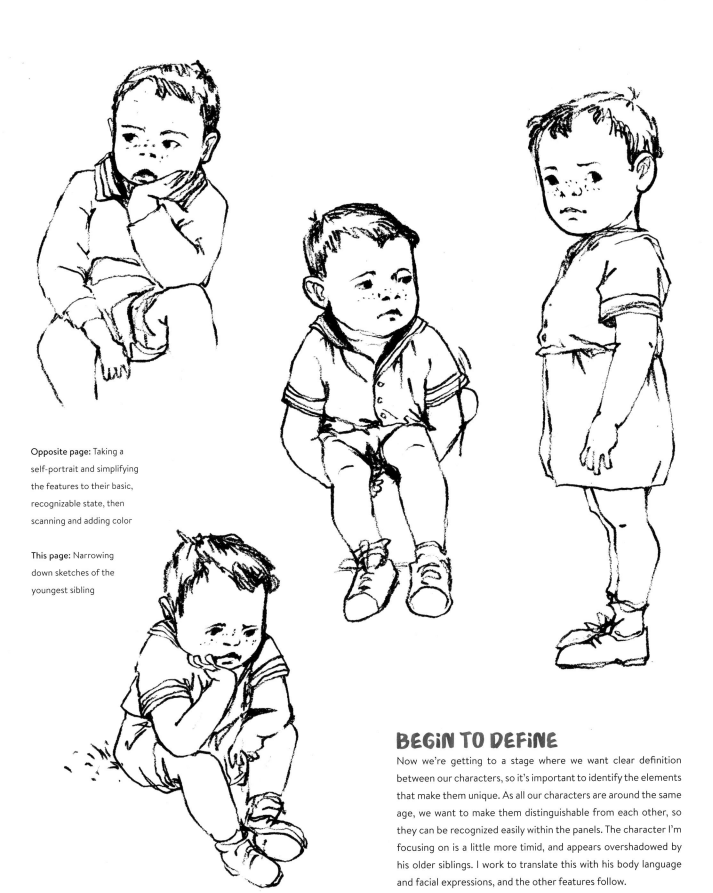

Opposite page: Taking a self-portrait and simplifying the features to their basic, recognizable state, then scanning and adding color

This page: Narrowing down sketches of the youngest sibling

BEGIN TO DEFINE

Now we're getting to a stage where we want clear definition between our characters, so it's important to identify the elements that make them unique. As all our characters are around the same age, we want to make them distinguishable from each other, so they can be recognized easily within the panels. The character I'm focusing on is a little more timid, and appears overshadowed by his older siblings. I work to translate this with his body language and facial expressions, and the other features follow.

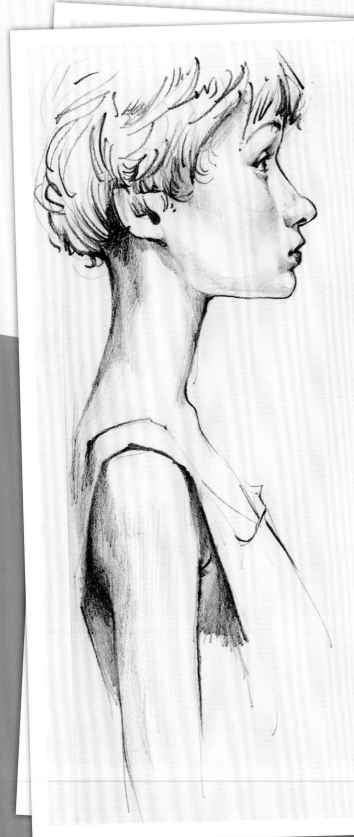

TAKING SKETCHES FORWARD

One of my favorite things to do is to scan an image straight from my sketchbook and use it for an illustration. The beauty of sketches, especially with pencil on paper, is their charm, textural quality, and expressiveness. Try scanning your sketches, setting them to Multiply in Photoshop, and coloring underneath them. Or you can try coloring them traditionally – the best thing is just to keep that playful quality of the sketch.

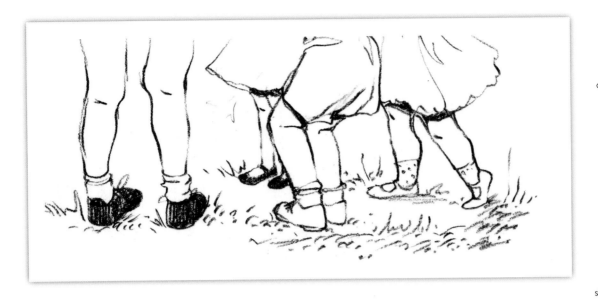

This page (top): Shift the focus of your sketches to help develop smaller details within the characters

This page (bottom): Here I'm defining the features of Cyril, the oldest sibling, and giving variation to his body language

Opposite page (top): Early thumbnail sketches for two pages of the comic layout

IT'S THE LITTLE THINGS

A lot of what defines a character can be found in smaller details, so it's important to include them in your sketches. I play around with some sketches of the children's feet and start to add little details that will help signify the individual characters. In this case, from the feet we can tell the older sibling has a power stance, compared to the eager stance of the younger sibling. Focusing on these little moments can give the viewer a different perspective of the characters.

CHANGE IT UP

Your sketchbook is a great tool for continuing to explore your characters and the features that define them. Plus, it provides great practice for repeatedly drawing your characters, as you would in narrative illustration or comics. You need to make sure your characters are instantly recognizable – try drawing them in a different pose, or with a different expression, and see what they look like in those moments. Sketchbooks are the place to do this, since they don't have to be perfect. You can pick and choose moments from your sketchbook to develop further.

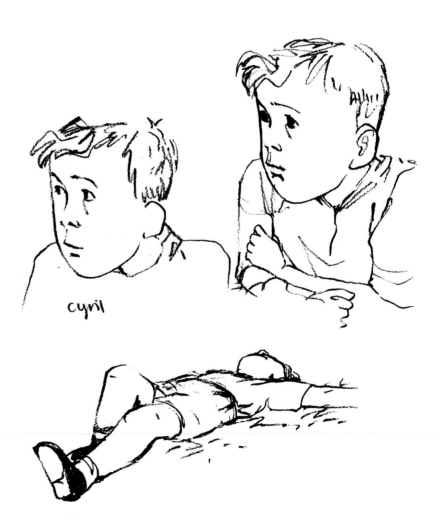

cyril

LAY iT OUT

Sketchbooks can also be used for thumbnailing and making plans for upcoming projects. They are a place where you can work loosely, making the task ahead less daunting. Use this time to experiment and keep it simple – you can move things around and see what looks best, deciding where each element will go. Create little rectangles the same size proportionally to the final size you'll be working at, mark out the panels, and allow your characters and their world to breathe.

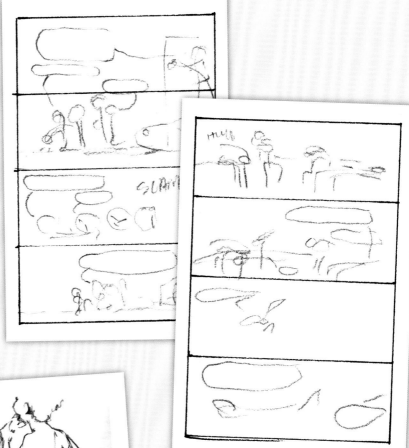

NOT ENOUGH STORY

Your sketchbook is a place to try out new ideas, and not all of them will make the cut. Here's a sketch I did of a boy who has just met a giant in the woods. I rejected this as an idea because it didn't hold the curiosity and playfulness I wanted to portray in my final design. Many of the details, such as the pose, felt too rigid – I wanted the character to tell more of a story. I can always return to this concept later and produce more sketches to see if I can bring this particular character to life.

BRING IT TO LIFE

Once you've worked on all these different elements in your sketchbook, you can bring them together. The more time you put into the preliminary sketches in your sketchbook, the easier this will be. Having your sketchbook filled out with preparatory material will help you feel more ready, as you already have all the elements in front of you. For example, above you can see Cyril drawn in red. I've taken the elements I defined within my sketchbook and was able to use them to translate the different emotions, expressions, and poses across the panels.

KEEP THINGS FRESH

As your work moves out of your sketchbook and into your final piece, it's good to retain the expressiveness that your initial sketches held. It's easy for pieces to become overworked when they are redrawn many times, so try to use material from your sketchbook as much as you can. This is where practice makes all the difference, because your sketches for a final piece will have more life in them. Try to hold on to the dynamism and charm they had in your sketchbook.

Opposite page:

Placing Cyril in the
scene in various poses

This page:

The finished page of
the comic, colored
and ready to print

CHARACTERIZE THIS:
JOLLY GEODE
MARVI MANZONI

This piece will show how it's possible to develop a character from two simple words – an inanimate object, "geode," and an emotion, "jolly." As someone who works in children's animation, I'm used to making quick decisions when designing characters. I will show you how I approach this kind of brief in my everyday job, and the different steps I take to tackle it.

WHO IS THE CHARACTER?

The first step is to gather ideas for who the character might be. What do I think when I read the words "jolly geode?" For me, geodes are very magical, and "jolly" could mean a funny animal. When I combine magic and animals, I think of familiars. Now, what context could I place my character in to make them appear jolly? Maybe they are playing or interacting with a human owner?

WHY JOLLY?
CUDDLES

OBJECT? PET?
PET

WHO IS THE CHARACTER?

OWNER?
WITCH

THEME?
MAGIC

SIZE?
BIG

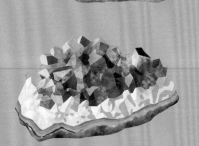

RESEARCH!

Now we have a starting point, it's time to begin looking for references through the internet, books, movies, and in everyday objects. Research often influences building the back-story of your character. I like to use the references to refine my idea, rather than to search for an initial one.

DRAW YOUR OPTIONS

Children's animation is a fast-paced environment with little time to explore your options, so having a clear idea and selecting useful references is particularly important. I draw some quick, rough sketches to block the shapes and designs, and then choose three or four to clean up.

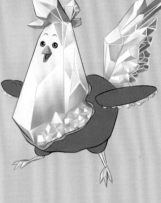

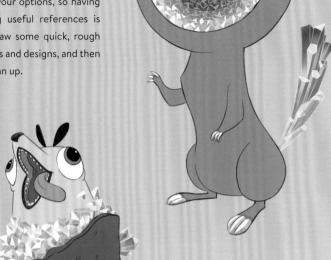

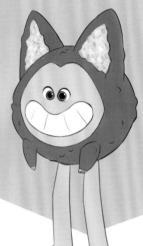

POSES

I choose the sketch that appeals to me the most, and best fits the brief, then move on to poses. I tend to sketch these quite quickly. Once I'm satisfied with the positioning, I add a new layer on top and clean up the lines until I'm happy with the result. In my everyday job, these poses are used as references by the riggers, so it's important that they are cleaner than the rough sketches in the previous step.

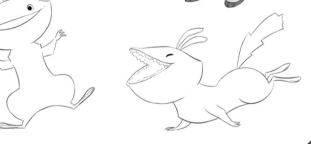

TAKE A MOMENT AND BREATHE!

It's easy to panic when you receive a brief that's out of your comfort zone. Breathe, take a moment, and then try to relate it to an area you feel confident about. Start sketching and often the ideas will start coming to you. Don't forget to ask friends for their opinion – talking with someone else often helps you string together your thoughts or see things in a different light.

COLOR KEYS

With a bit of color, a simple silhouette becomes an interesting character. Working for a CGI studio, my goal is to achieve volumetric rendering, in order to inform the texture artist of the different texture and materials of the character. For this, I use the Multiply and Overlay blending modes.

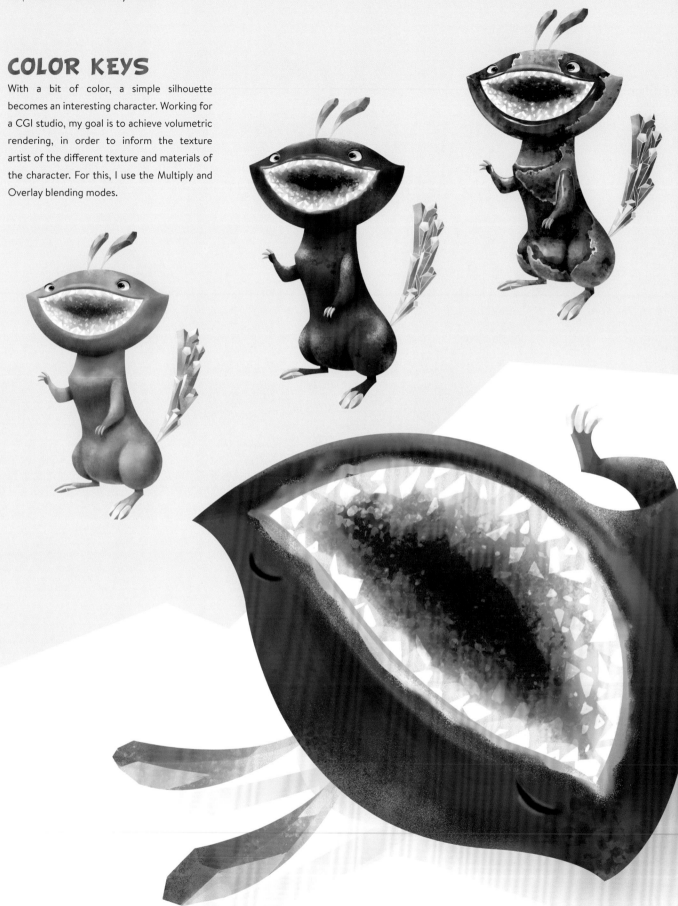

FINAL ILLUSTRATION

Since the emotion I need to convey with this character is "jolly," every design choice selected for the image needs to accentuate this feeling and convey the emotion to the viewer. I picked this as the final pose as I considered it a relatable moment of joy between the two characters, allowing the emotion of the piece to be conveyed faster.

STUDIO SPOTLIGHT:

TAIKO
S T U D I O S

Following the success of their short film *One Small Step* in 2018, the cross-continental Taiko Studios
have gone from strength to strength. In this interview, founder Shaofu Zhang and director Andrew
Chesworth join us to discuss the studio's beginnings, the challenges of working across time zones,
their vision to create stories with heart, and much more.

Thanks for taking the time to chat to us today. Can you tell us how the studio began, and how it has evolved over the years?

Shaofu: Hello, it's great to be here! Taiko Studios was founded after I received a grant from the city of Wuhan to invest in a studio and short film. From there, we created *One Small Step*, our inaugural short film, which was really well received. Since then, we've been developing some projects internally, and also partnering with other studios and companies to create projects that bridge East and West through animation.

Andrew: I was invited by Shaofu, Bobby Pontillas, and a group of former Disney artists to join the team at Taiko. Shaofu pitched the goal of creating new variations of animated stories. *One Small Step* was designed as a calling card to represent the team and the work we wanted to create. Over the last few years, Taiko has created projects with fundamentally Eastern subject matters that also incorporate the perspectives of Western artists. We have cultivated an art style that lives comfortably between 2D and 3D, and many collaborators now seek us out for our style and approach.

You have one studio in Wuhan and one in Los Angeles. Are there any differences between the work you do at the separate locations? Do you share work between the studios?

Shaofu: The locations depend on each other for all the projects that our studio as a whole produces, but they do have different functions. The L.A. studio has the show directors and producers, plus the pre-production departments that focus on story and visual development. Then the Wuhan studio brings those ideas to life by creating all the assets, animating the scenes, lighting and compositing the footage, and bringing everything to a final look. There is daily communication across the locations via video conferencing, so the director can ensure quality control, and so that any questions that arise during the production process can be addressed.

Opposite page: In *One Small Step*, the shape language for Papa Chu was characterized by strong, sharp shapes, while Luna as a child reflected soft curls and curves

This page: *Young Luna's Birthday* – the layout of the environment was purposefully designed to pull the viewer's eyes toward the characters

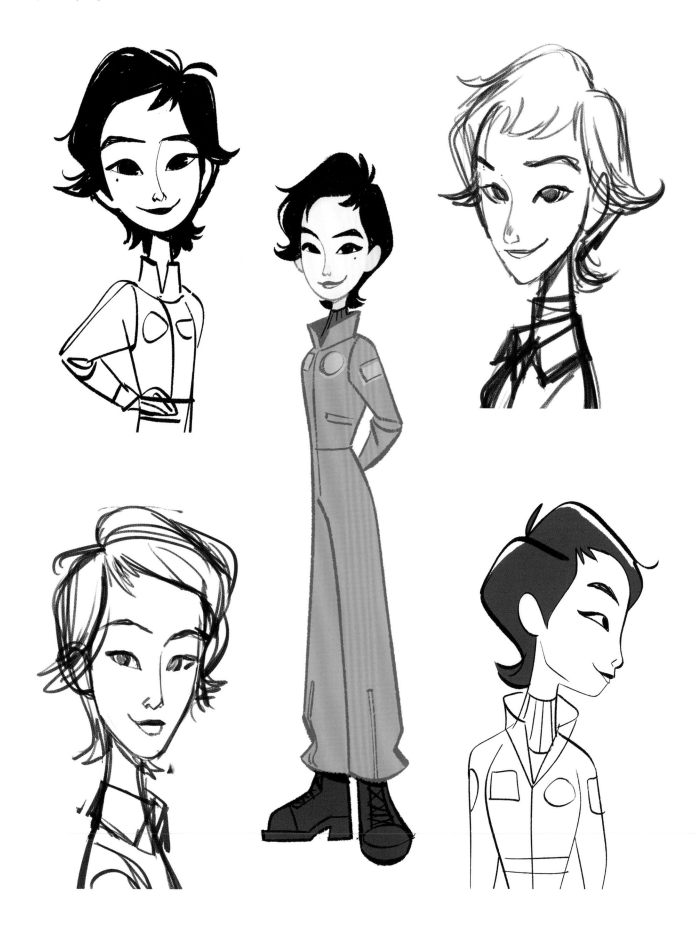

"We try to find the common shared values between Eastern and Western cultures"

As a studio that bridges Eastern and Western sensibilities, what unique challenges does this bring you?

Shaofu: As a studio with an American and Chinese presence, we try to find the common shared values between Eastern and Western cultures. Sometimes it is a challenge to find that sweet spot, however I've found we have so much more in common than we have differences. I hope in our work we can celebrate that universality that we share.

Andrew: On a practical level, the challenge of the time-zone difference between the studios can be a chronic stressor. As for creative challenges, our audiences and clients are highly attuned to authenticity in the work, so communication within the team is really important to ensure we successfully present stories and characters that resonate in a culturally specific way.

What kind of projects are you currently working on? And what project has been your favorite in recent years?

Shaofu: We have a few short film projects on the go, which will be released next year, as well as feature and series projects that we have been developing internally. There are aspects to every project we do that are very special to me. With each new project, we try to push at least one or two aspects in a whole new direction, in a way we've never done before, to drive the medium forward and keep things fresh and interesting.

Andrew: We're currently executing various commercial and vendor work, in addition to developing pitches for animated feature and short films. I think *One Small Step* is the project I've loved being part of the most at Taiko. For me, it represents the best of what our studio has to offer.

Opposite page:
Development sketches of
adult Luna in full-length and
from various perspectives

This page: Various head
perspectives of adult Luna

How many people usually work on a project? Who is involved in a production and what is the process?

Shaofu: The overall scale of the project determines how many people will be devoted to its production. For larger projects, we use everyone on staff, starting with visual development and ending with the final edit. For smaller projects, only a handful of artists may be needed, or one person from each department. There are times when we are active on multiple productions at once, so we sometimes reach out to freelance artists to fill the need. For the most part, we have to be flexible to meet the needs of each project.

Andrew: Yes, it totally depends on the project. It could be anywhere from three people, if it's a design or writing assignment, up to 30 if it's creating an entire short film from concept to completion.

What does a regular day look like at Taiko?

Andrew: A regular day in L.A. usually begins with a check-in to look at new developments from overnight at the Wuhan studio. Creative tasks like writing, drawing, and animating occur throughout the day. When it's evening in California, it's morning in China, so that's when the video conferencing happens and everyone can get on the same page. Any questions or issues that arise are addressed in the meeting as well, and files are shared so that the next day of production can successfully begin.

What do you tend to look for when recruiting?

Shaofu: I look for that elusive spark that shows something unique or a fresh sense of perspective. With all our projects, we look for artists and creatives that can add that something special, whatever it may be. Beyond that, technical prowess is always something we look for – whether this person can take notes and execute them at a high level of understanding and interpretation.

Andrew: I look for the "X factor." Someone who has a unique artistic voice combined with strong technique. It's also important if the artist interviews well and seems like they will be a positive collaborator – that can make all the difference.

This spread: Clothes explorations for adult Luna

"I look for that elusive spark that shows something unique or a fresh sense of perspective"

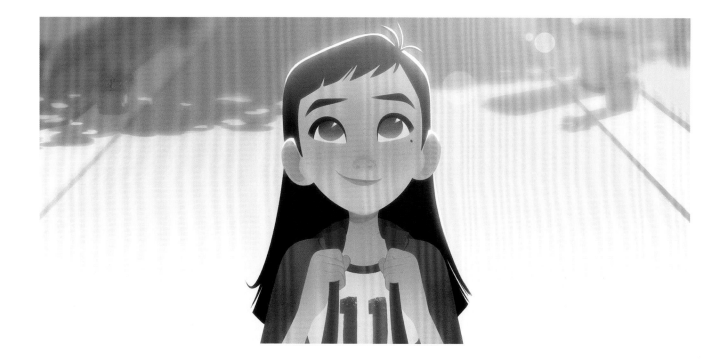

When it comes to character design, what do you consider to be the most important features to best connect to the viewer?

Shaofu: I engage with designs that tell me something specific about that character – if there's a story within the design that informs the viewer of an implied history. This can help bring depth and empathy before the viewer even knows the actual back-story. Beyond that, I'm looking for iconic appeal, clarity of shape, and simplicity.

Andrew: For me it's all about appeal, personality, shape design, solid drawing, informed choices, a sense of emotion, and performance in the expressions.

Your short films have a lot of heart – is this something you look for in your artists?

Shaofu: For me, the stories we tell have to come from a personal place, usually from a well of emotion, and say something meaningful. There should be a sense of honesty to the

concept that audiences can relate to on an emotional level. We very much look for artists that can become conduits for the emotions we try to present on screen.

Andrew: Definitely. Connecting with the audience is what this is all about.

What would you say are Taiko Studio's proudest achievements?

Shaofu: As a studio, having our first project reach such great heights of recognition was absolutely amazing, and something that, quite frankly, was unbelievable. I couldn't be more proud of our team, who are insanely talented and hard working. In addition, we've been lucky enough to continue work on projects that have allowed us to partner with amazing artists and storytellers from around the world.

Andrew: I'm immensely proud of the journey that *One Small Step* took when it was released into the world, and how it connected emotionally with audiences from all walks of life. I'm so proud of the team that came together to make it and the generosity they

displayed, pouring their hearts and experiences into the work.

What kinds of projects would you love the studio to take on in the future?

Shaofu: We're focused on projects that we can approach personally – ideas that have something honest and essential to say. We're also excited to continue to push the medium of animation forward with bold and fresh art direction.

Andrew: We're looking for anything that feels truly inspired and contributes something of fresh value to the animation industry.

This page: *Teen Luna* – we used warm colors and bounce light to convey mood as Luna approaches her school with vibrant optimism

Opposite page: Our lighting team on *One Small Step* carefully sculpted the rim lights and cast shadows to achieve the desired simplicity and appeal

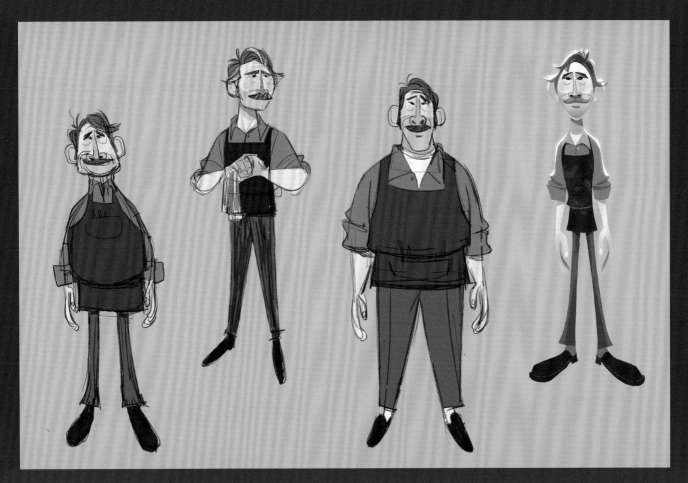

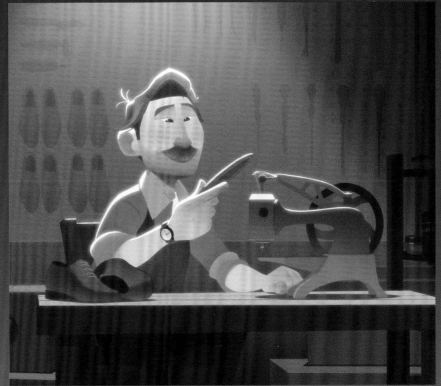

STYLIZING FANTASY CHARACTERS

TRUDI CASTLE

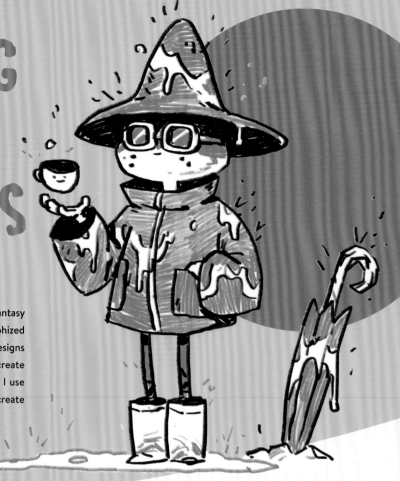

On these pages, I'm going to show you how to stylize relatable fantasy characters. For me, this means creating quirky, anthropomorphized animals doing everyday human activities. I always want my designs to be fun, silly, and even a little ludicrous at times – this will create a reaction from the viewer and draw them in to the designs. I use Procreate on the iPad Pro, using a standard pencil brush to recreate the look of color pencil sketches.

FANTASY FROG

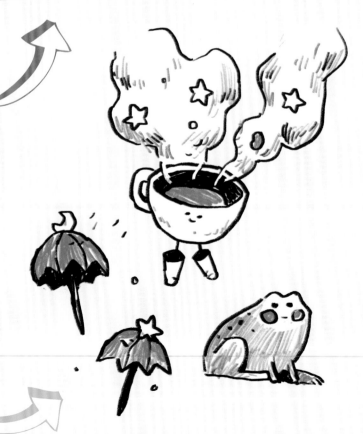

RAINY DAYS

Where I live in Vancouver, we get a lot of rain. I decide to take inspiration from this and research animals that like wet weather, then I start to think about human tasks I want the animal to perform. I imagine a frog going through my usual morning routine – drinking coffee on my front porch while it drizzles outside. I add some relatable elements, such as a raincoat and swimming goggles, for a bit of humor. To add a sense of fantasy, I give him a magical hat and have his morning coffee floating above his hand.

FROG-CEPTION

Next I want to add even more features to the magical frog. For some whimsy, I add a mini umbrella to the top of his hat and give him a mini frog friend. Showing anthropomorphized animals and regular animals side-by-side will help bolster the fantasy theme of the design – as it's difficult to pin down who or what this creature really is. A little steam rising from the coffee cup helps brings the scene alive.

KEEPING IN SHAPE

When stylizing a piece, it's always a good idea to play around with size and proportion. For this design, I feel the proportions of the frog can be pushed further. To do this, I enlarge the head of our main character to create more contrast between him and the realistic frog. To put in a little more detail, I add fur lining to the fantasy frog's boots – this is a fashion-forward frog after all.

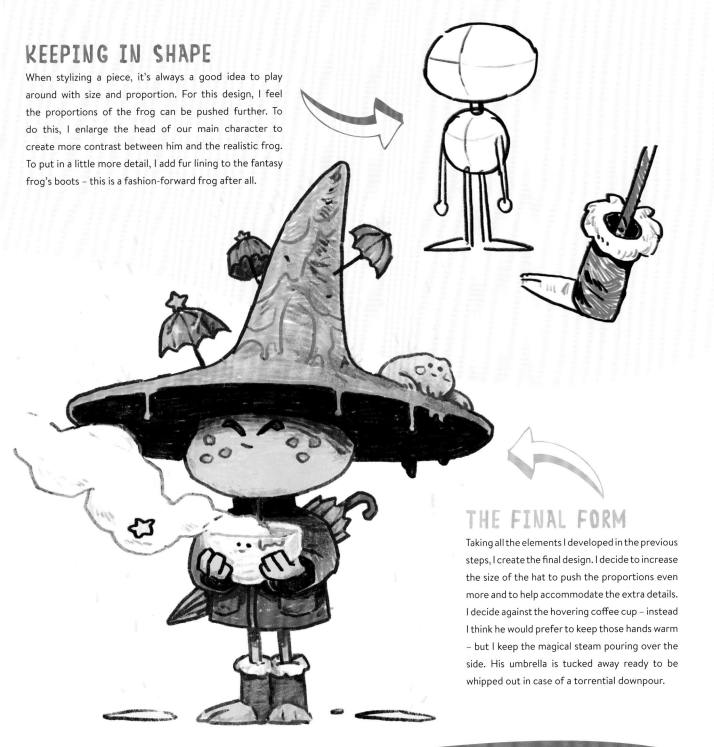

THE FINAL FORM

Taking all the elements I developed in the previous steps, I create the final design. I decide to increase the size of the hat to push the proportions even more and to help accommodate the extra details. I decide against the hovering coffee cup – instead I think he would prefer to keep those hands warm – but I keep the magical steam pouring over the side. His umbrella is tucked away ready to be whipped out in case of a torrential downpour.

DRAW FROM EXPERIENCE

Images that depict everyday occurrences are relatable and will resonate with the viewer. Drinking in the rain or carrying a heavy bag are activities we have all experienced at some point in our lives. These relatable scenes feel more heartfelt, as you are not just following current trends, but instead putting a little of yourself into your designs. Put a spin on your everyday activities and see what you can create.

CURIOUS CAT

CURIOSITY KILLED THE CAT

When imagining what kind of human characteristics or activities to attribute to animals, I like to study their features and see what suits them. Cats tend to have large eyes, which I imagine to be seeking knowledge. From this, I imagine a cat who attends school and explore two options for the design – one cat who wears glasses and a tie, and another who is a little rough round the edges – an "alley cat."

THE BARE NECESSITIES

Regardless of my cat's personality, I want them to appear studious and eager to learn. I decide to draw them piled up with all the things they need – a thick heavy book, a big fluffy quill to write with, and maybe some energy potions thrown in for good measure. I decide to go against the obvious choice and settle on the alley cat, as this will create good variation within the design.

SIZE UP

Once I have drawn all the line-art of the cat and his overflowing backpack, I start to play around with size. I want to create some contrast between him and the backpack, but I don't want him to be overpowered by it. I play around with a few different sizes, but decide to go with the design that does not draw the viewer's eye away from the character itself.

THE BIGGEST BACKPACK

This is a cat who heads to school over-prepared – with his backpack full of all the essential tools and potions to get him through the day. The excess of bottles suggests he is studying to be a potions master – maybe he'll create something that can heal the big scar on his face. He appears strained under the weight of it all through his pose, but he still looks determined to learn.

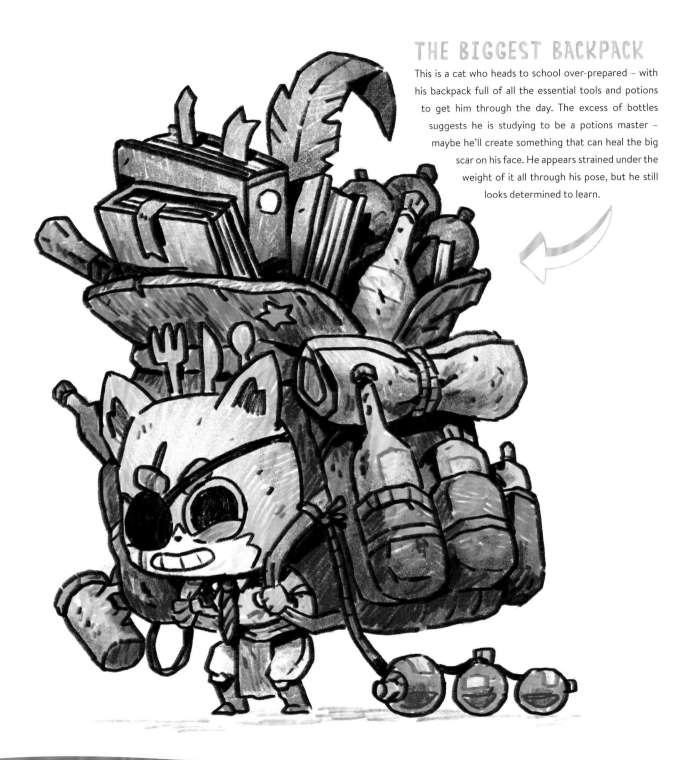

HATCHING A NEW IDEA

One of the first art techniques I learned was hatching. At the time I thought nothing of this simplistic technique, but it has slowly crept its way back into my work. It is a highly effective technique, as with a few simple lines you are able to convey more volume, even with simple outlines and flat colors. Give it a try!

THE GALLERY

In every issue we hand select artists who specialize in character design and character-based artwork to showcase the high standard of work created by those in the industry. This time around we have eye-catching artwork from Iz Ptica, Nathanna Erica, and Lea Embeli, whose distinctive designs shows how broad and liberating the topic of character design can be.

Iz Ptica | izptica.com | Images © Kaja Kajfež

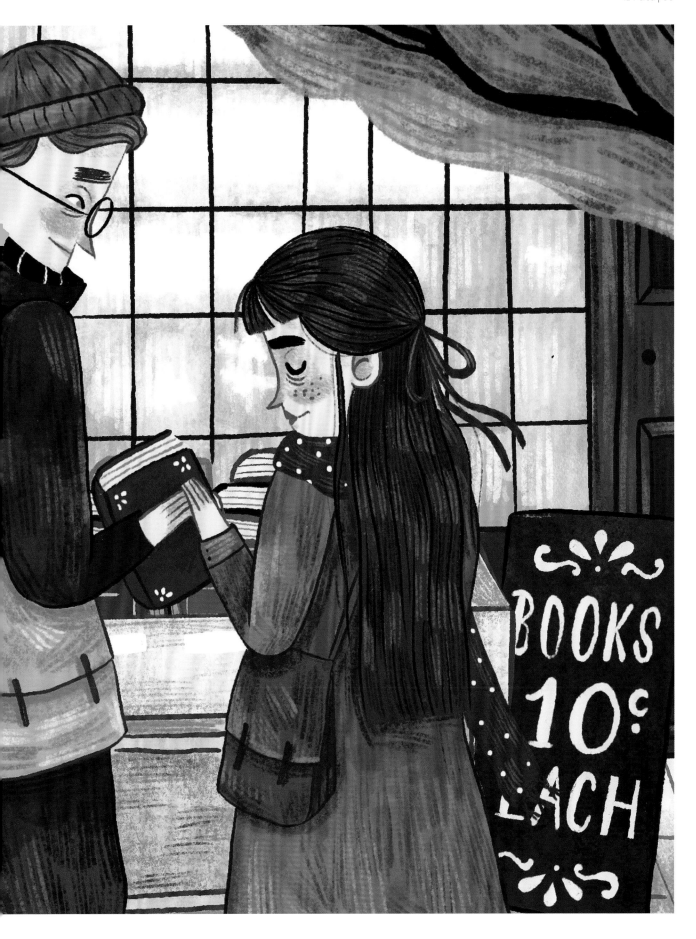

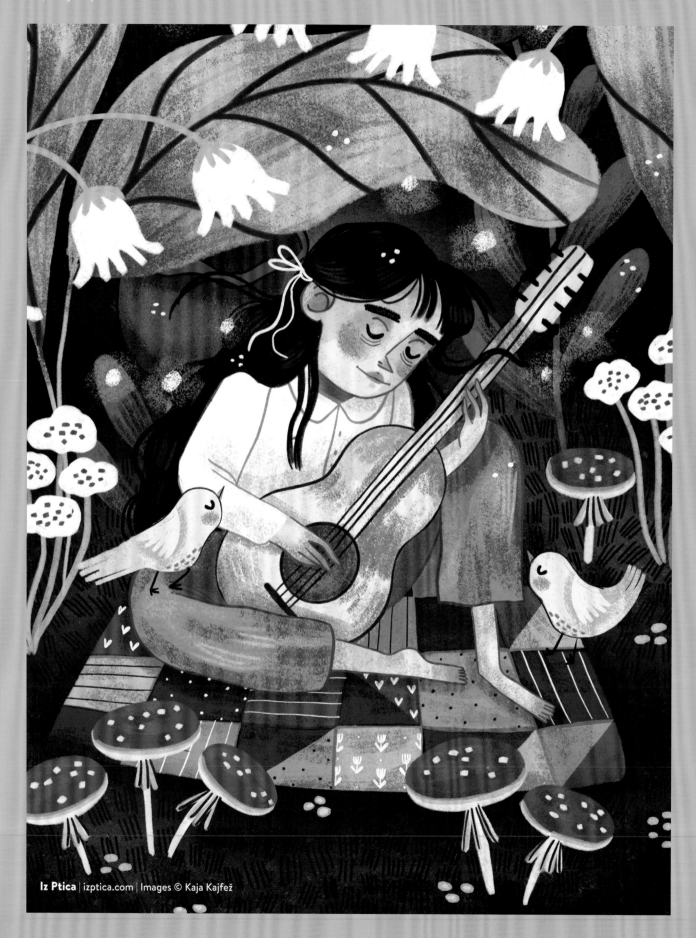

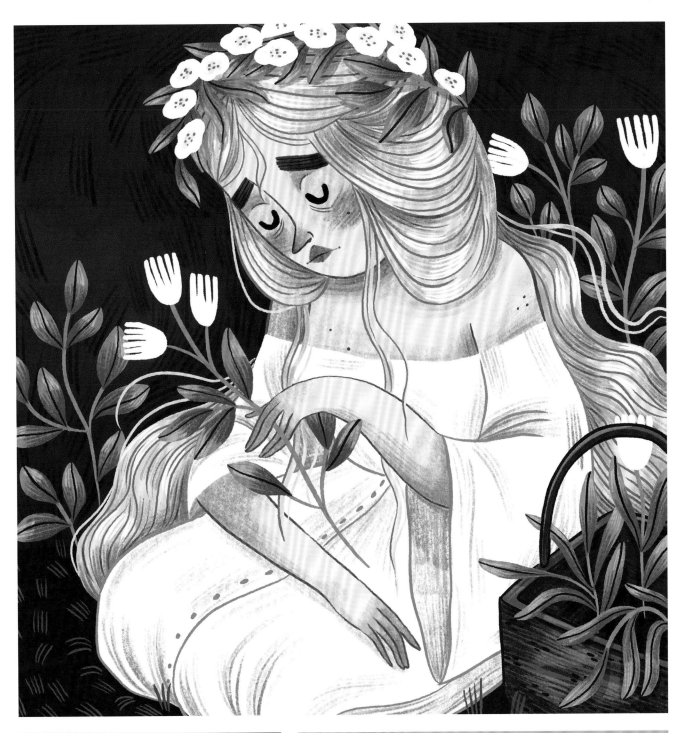

KAJA, THE CREATOR BEHIND "IZ PTICA," LOVES TO TELL STORIES THROUGH THE VISUAL MEDIUM. AS A FREELANCE ILLUSTRATOR SHE FOCUSES ON CHILDREN'S BOOKS. IN HER PERSONAL PROJECTS SHE EXPLORES CHARACTER AND EMOTION THROUGH HER LOVE OF NATURE. AS A SMALL SHOP OWNER, HER CREATIVE CAREER FEELS LIKE A DREAM COME TRUE!

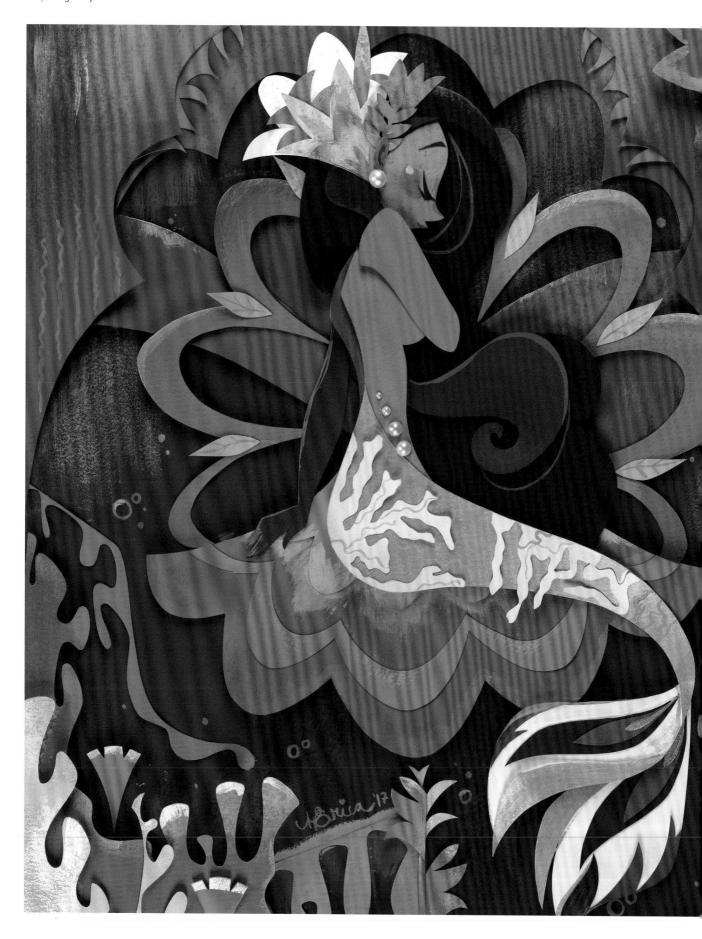

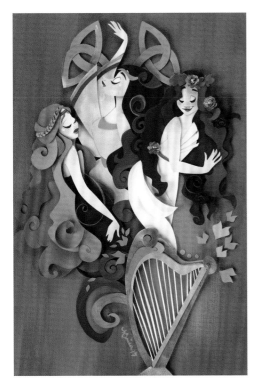

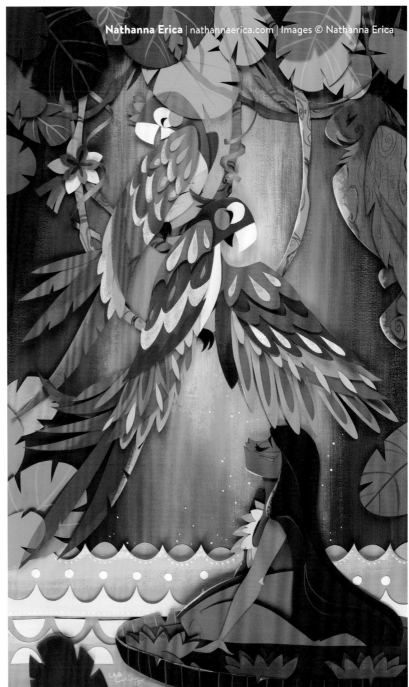

Nathanna Erica | nathannaerica.com | Images © Nathanna Erica

AN ILLUSTRATOR, DESIGNER, AND PAPER ARTIST FROM BRAZIL, NATHANNA WAS BORN INTO A COLORFUL AND VIBRANT COUNTRY, WHICH IS REFLECTED IN HER WONDERFULLY TEXTURED DESIGNS. FOCUSING ON ILLUSTRATION AND VISUAL DEVELOPMENT, SHE HAS TAKEN TO FREELANCING WHILE ALSO EXPLORING HER LOVE FOR PAPER CRAFTING.

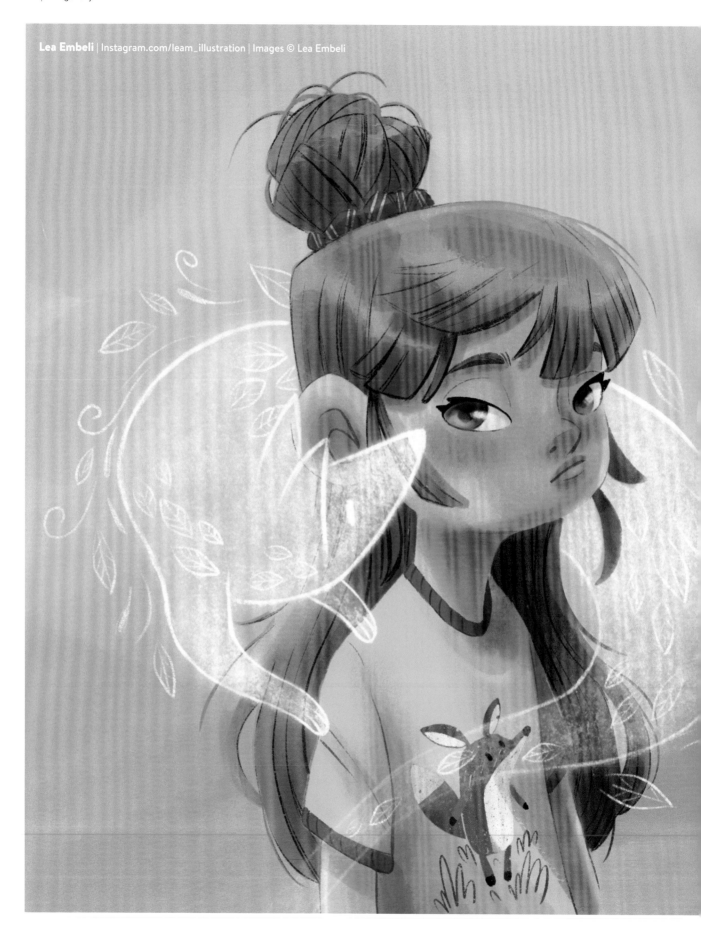

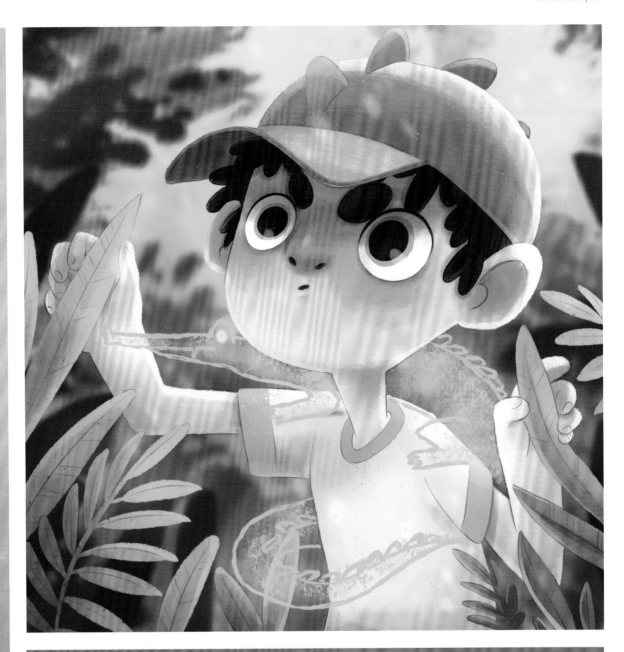

LEA, AN ILLUSTRATOR FROM SERBIA, COMPLETED HER ARTS DEGREE IN 2018. SINCE THEN SHE HAS ILLUSTRATED SEVERAL BOOKS FOR SERBIAN PUBLISHING HOUSES, AS WELL AS MULTIPLE BOOKS FOR FOREIGN PUBLISHERS. SHE CURRENTLY LECTURES ON PAINTING TECHNIQUES AT THE FACULTY OF APPLIED ARTS IN BELGRADE.

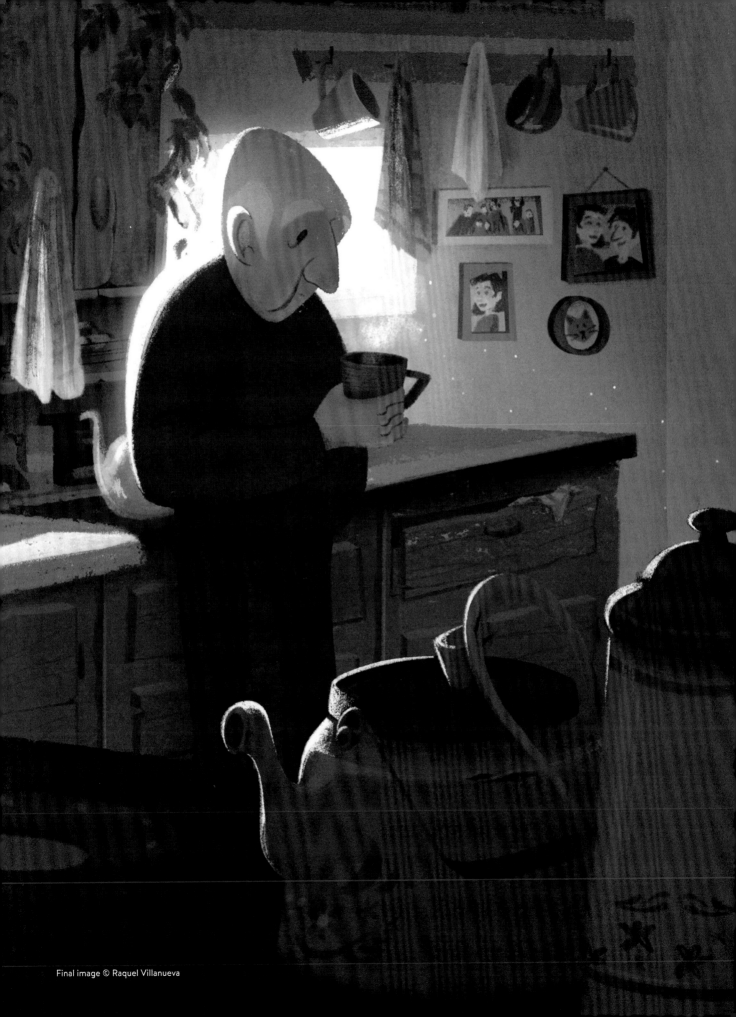

STORYTELLING AND ATMOSPHERE
RAQUEL VILLANUEVA

As artists we are constantly telling stories. Sometimes these are simple, providing essential information such as the colors our character likes to wear, or insights into their personality or attitude. But when we want to go further, we can push it more and create a whole backstory for them. In this tutorial, I will show you my process from finding an idea, developing it, and executing it to create a full composition, telling the story of a character.

A FRESH IDEA

When you create something new, you can sometimes feel overwhelmed by the endless possibilities. To avoid this, I try to start with a very simple idea, then play around with it and push it in different directions. In this case, I want to work with the feeling of nostalgia – that bittersweet feeling that we have all experienced at some point in our lives, especially during recent uncertain times. Nostalgia is often associated with the past – it makes us feel both happy and sad – so how can we translate this into an image? It's helpful to begin by thinking about things that make us feel this way. I know I want a scene that depicts real-life, during those early or late hours of the day that have a quiet and calming atmosphere.

WARM-UP

One of my favorite things to paint when I want to get my creative juices flowing are these little landscapes. I keep them very simple and graphic, but they help inspire me and get me into work mode. Warm-ups can also be a great time to experiment with color palettes.

"WARM-UPS CAN BE A GREAT TIME TO EXPERIMENT WITH COLOR PALETTES"

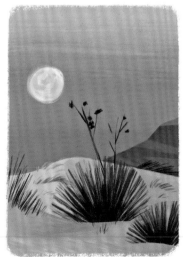

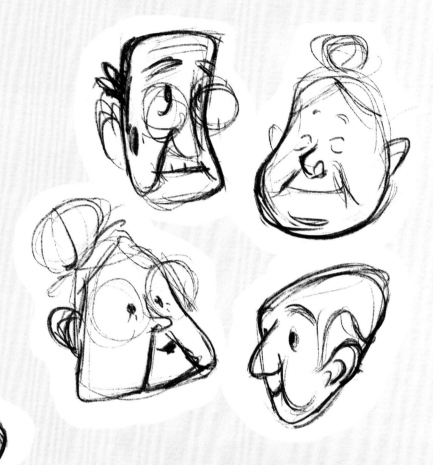

MEETING OUR CHARACTER

Once you have the initial ideas, you can start to build the main character of the story. I opt for an older person because they are full of life experiences, which is useful when creating a backstory. Make some sketches to find an interesting design that could work with the story. At this point, keep it loose and simple.

GETTING TO KNOW YOU

After exploring some options, I decide on this particular elderly gentleman. He evokes a warm feeling, like a grandpa who would hug you and tell you stories. He has a simple silhouette and shapes, and not too much detail, which will work well as I want to create a busy background. He'll be wearing some pajamas or cozy leisure-wear to make him look more relaxed.

Opposite page (top): It helps to begin by mind-mapping lots of concepts and ideas

This page (top): Explore different ideas without becoming too committed to a full sketch

This page (bottom): Explorations into the chosen character

SETTING THE SCENE

To begin the background design process, first create quick sketches to see which compositions work better. It's important to push yourself, to test out different approaches and move away from your initial ideas – this will help give variation to your design. The final thumbnail has a simple composition, where the character can begin his day on a quiet morning and become lost in thought.

DELVING INTO THE PAST

You might have come across the common misconception that using reference is cheating – this could not be more wrong. Looking for reference and using it is as important as the execution of the painting itself. Take your time to look for inspiration. For this piece, I researched old, rustic kitchens, and it helped me figure out what would look good, and what would help portray the mood. I searched old houses, vintage objects, and images that maybe don't have a lot in common with the concept, but have a similar feel or colors that can be carried over.

This page (top): Composition sketches to plan the background scene

This page (bottom): Reference images help define the space the character lives in

Opposite page (top): Start to refine the sketches with added details

Opposite page (bottom): Tell the story through the items in your character's space

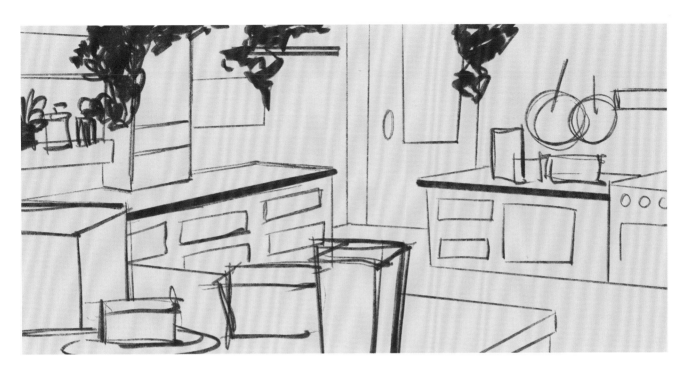

SKETCHING THE DETAILS

Now we can begin taking our sketches to the next step. Go back to the chosen thumbnail and clean it up by sketching over the details you want to define – in this case, the elements for the kitchen. Taking information learned from the research, I play around with different ideas for the countertops, stoves, and other accessories. At this point you can also adjust the composition if you feel it's needed.

KITCHEN CLUTTER

After the research stage, I have many ideas on how to fill the interior. To help build the personality of our character, I want to fill the space with kitchen tools and gadgets. This will help it feel much like our own grandparents' kitchens, where it might be a little messy, but not too cluttered and chaotic – just full of the things they have collected over the years. I add old-fashioned tools and stylize their shapes to make them easy to read. I also make them age-worn to help emphasize the storytelling element of our image. I add some smaller details too, such as framed pictures showing our grandpa when he was younger. This gives more interest to the visual storytelling we are establishing in the piece, and the viewers are invited to make their own conclusions about who the people in the frames are.

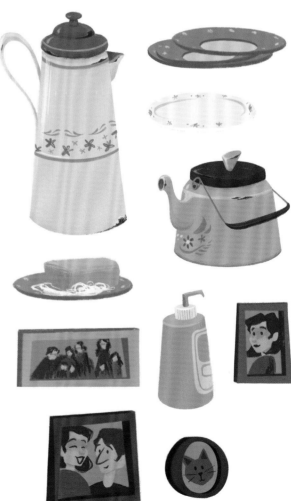

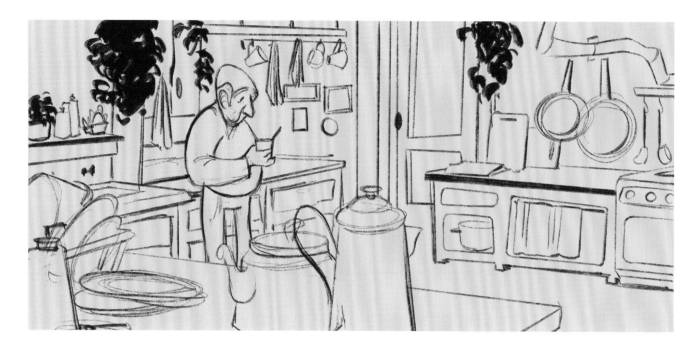

COZY KITCHEN

Now it's time to clean up the space and introduce our character. I pose the character with his back against the window – this combined with the light leading into the interior will help the viewer focus on what's going on inside the room. The elderly man's thoughtful gaze into his mug will make the viewer wonder what he's thinking, evoking that feeling of nostalgia I'm aiming for. It's these subtle choices that can help to tell a story – elements that will help the viewer understand the character's mood and make them want to know more.

LIGHT AND DARK

Usually I jump straight into coloring the character, but since this is a larger piece, I would like to check the values first. Values are a helpful guide when moving on to color as they help establish how light or dark areas of your image will be. It's a good idea to make a rough pass to define the values of all of the elements within the composition – this helps you see if there is enough contrast in the piece to make it easily readable for your viewer.

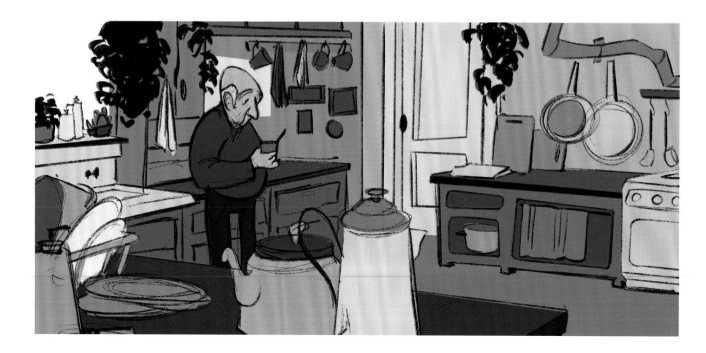

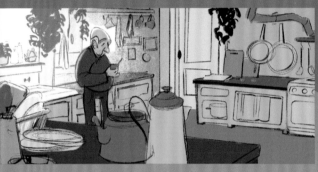

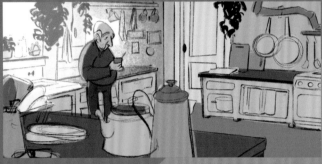

ADDING WARMTH

Now comes my favorite part – adding color. At this point it's best to explore and test different color palettes; much like with the sketching step, it's good not to stick with the obvious or initial choice. Color is a strong tool to communicate and generate sensation from your viewer, so think about what you want to convey with your color choices. For this piece, I choose warm colors to create a homely vibe.

Opposite page (top): Pose your character in the scene in a way that will focus the viewer's attention

Opposite page (bottom): A rough values sketch to check the dark and light levels

This page: Color palette explorations and a photograph of me at work

A SPLASH OF COLOR

Once you've selected a color scheme that works, you can block the base colors of everything within the composition. Group the elements in different layers so they are easier to work on – this is especially helpful later on when adding texture and lighting. I separate my composition out into four layers: foreground, props, character, and background. I tend not to need more than that. Try not to go overboard separating every item on a single layer, as that can get annoying and messy when you work on later steps.

"BLOCK THE BASE COLORS OF EVERYTHING WITHIN THE COMPOSITION"

COLOR VARIATION

I like to add some textured color variation to the local colors to avoid monotony and achieve a more interesting result. You can also play around with different tones of the base color and mix them with complementary colors, or colors you have used in other areas of your design.

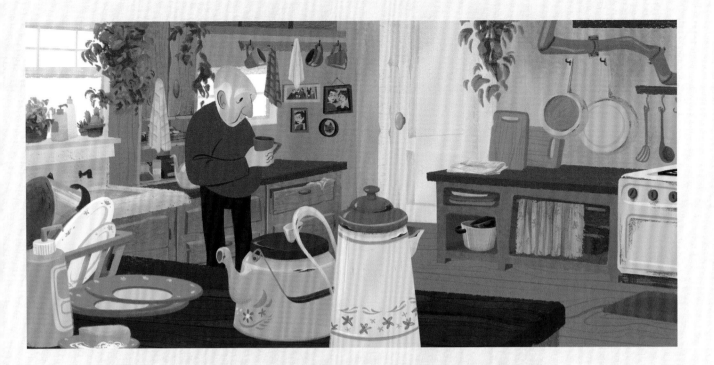

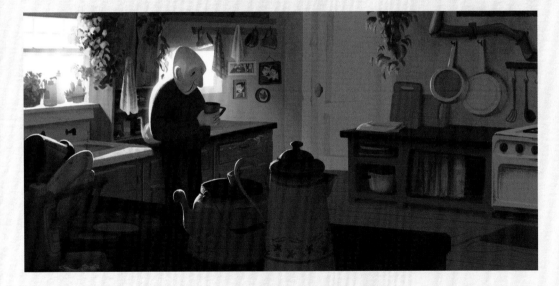

HOMEMADE

I prefer my work to look expressive and stray away from the more digital look, so I like to use a lot of textures when I'm painting. I pay special attention to the edges of the shapes, making sure they don't have perfectly defined lines. This makes them look like they've been drawn in chalk or gouache. Another way to create this look is to avoid smoother airbrush tools and instead go for chunkier, gritty ones to give the more organic texture.

RISE AND SHINE

At this stage, we are nearly finished with our design and it's time to move on to shading. This will change the mood and help set the atmosphere of the whole painting. As mentioned in an earlier step, I have set this scene in the morning, so I add a strong light source from the rising sun coming through the open windows. You can emphasize strong light by adding rim light on the objects in the foreground – this makes them stand out from the shadows and creates some interesting lines around the silhouettes of the kitchen gadgets. I also add some extra brightness to the plant leaves in the window by over-painting them with a very bright saturated color that's somewhere between green and yellow.

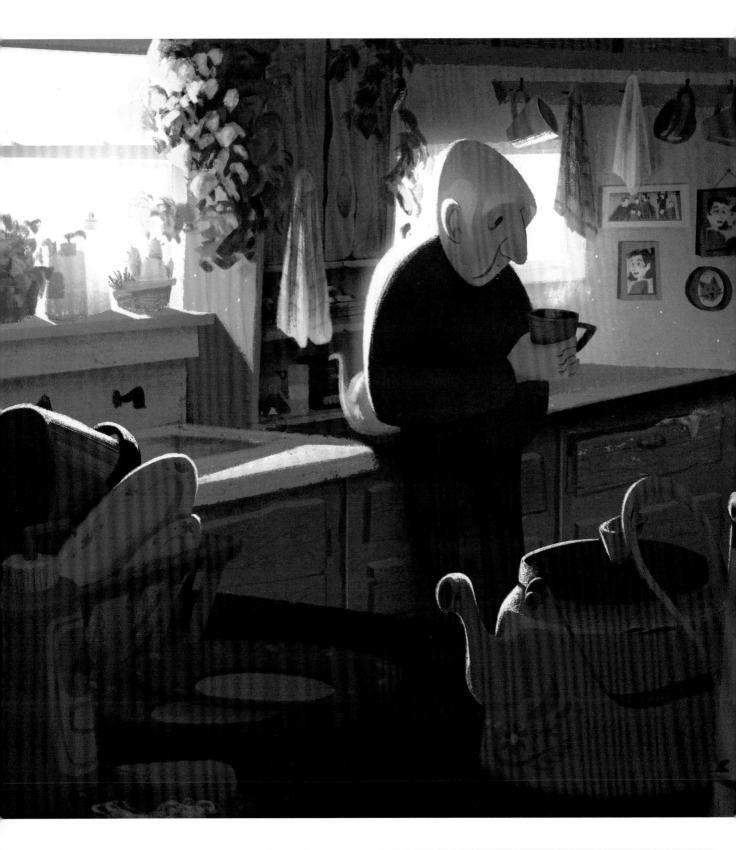

EARLY BIRD

Finally, it's time to add some subtle details to pull the piece together. To accentuate the nostalgic atmosphere I want to portray, I add a little extra texture to help the image feel cinematic. I also add floating dust around the light source to make the scene feel more alive. As a final touch I adjust the contrast and darken the corners to add depth – and it's done!

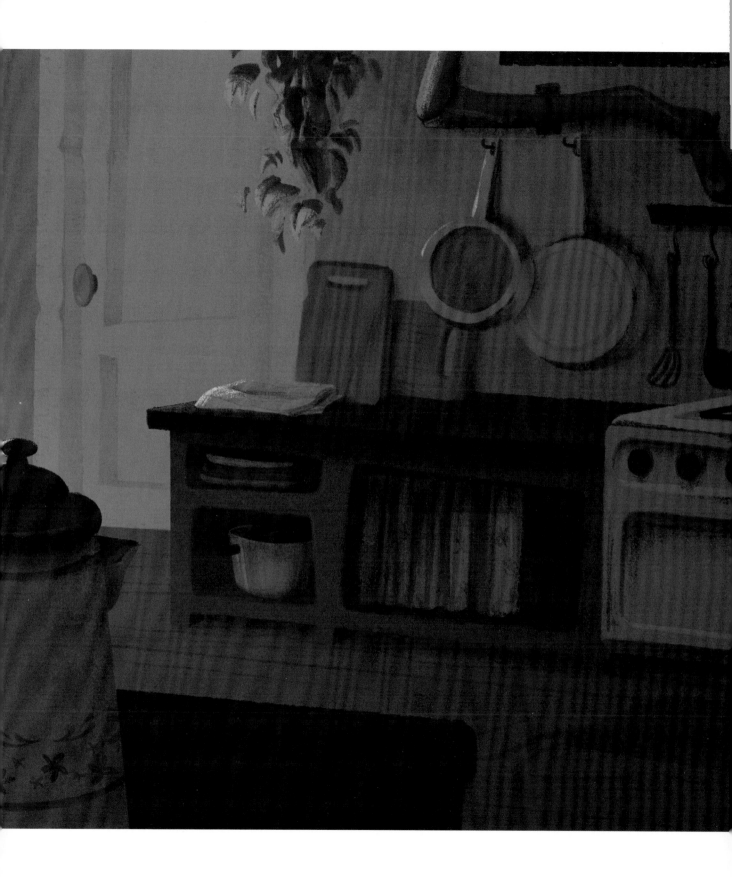

CONTRIBUTORS

JAMES A. CASTILLO
Freelance director and
character designer
murfishart.com

James is a Spanish art director and
designer based in London. He's a
big lover of spicy food and is at the
forefront of VR animation projects.

TRUDI CASTLE
Senior artist at Red Hook Studios
trudiart.com

Trudi currently lives and works in
Vancouver as a concept and game
artist. She loves coffee, hiking,
dinosaurs, and videogames!

MADISON HARPER
Illustrator
madisonharper.myportfolio.com

A recent graduate of Missouri State
Univeristy, Madison is now pursuing
her career in illustration, sharing her
drawing obsession with the world.

DEVIN ELLE KURTZ
Lead background painter
on *Disenchantment*
devinellekurtz.com

Devin is a visual development
artist and background painter for
animation. She exhibits all over the
U.S. and runs an online art business.

MARVI MANZONI
2D design team lead at
Brown Bag Films
marvimanzoni.com

Marvi is an Italian designer living
in Dublin. She currently works in
animation at Brown Bag Films as a
character designer.

CHRIS PALAMARA
Freelance character designer
chrispalamara.com

Chris is a character designer and
art director based in France, with
over 10 years experience in creating
characters for games and animation.

JOAKIM RIEDINGER
Lead animator and concept artist
jouak.com

Joakim has worked on several
critically acclaimed projects. He
recently won an Annie Award for his
work on *Spiderman: Far from Home*.

TAIKO STUDIOS
Shaofu Zhang and
Andrew Chesworth
taikostudios.com

Taiko is an award-winning animation
studio based in L.A. and China.
They are focused on bringing East
and West together in their work.

NÚRIA TAMARIT
Freelance illustrator
nuriatamarit.com

Nuria is an illustrator and comic
artist. She has recently self-
published several works and loves
to share her experiences.

RAQUEL VILLANUEVA
Freelance visual development
artist and illustrator
raquelvillanieva.es

Raquel is a 2D artist based in
Madrid. She has also dabbled in
the world of TV, feature film, and
children's book illustration.

EYE DIRECTION

BY LORENZO ETHERINGTON

THIS IS WHY, WITH *STYLES WITH BIG EYES*, WE OFTEN GET *"STARING SYNDROME"*!

THE LESS WHITE WE SEE...

...THE HARDER TO UNDERSTAND THE **EXACT** DIRECTION...

...THE RESULT IS A FEELING OF LOOKING IN A *"GENERAL"* DIRECTION.

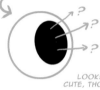

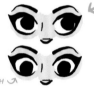

LOOKS CUTE, THOUGH

WE CAN *FURTHER EXAGGERATE* SIDEWAYS LOOKS BY *THINNING, OR PUTTING A BREAK IN,* THE *EDGE* OF THE EYELINE WHERE THE EYE *TOUCHES:*

THIS WORKS, BUT...

...BREAK EYE LINE...

...EVEN CLEARER DIRECTION!

IF YOUR STYLE'S **MORE REALISTIC,** JUST THIN THE EYE LINE MORE SUBTLY

TO *COUNTER* THIS, YOU CAN UTILISE A HOST OF *OTHER ELEMENTS* TO HELP GIVE YOUR CHARACTERS A LITTLE MORE *FOCUS...*

USE **HEAD ANGLE** TO LEAD THE ENTIRE FACE IN THE SAME DIRECTION AS THE EYES

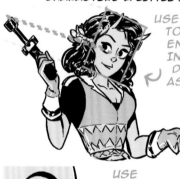

AS OUR **COMPREHENSION** OF THE **DIRECTION** THE EYE IS LOOKING COMES FROM THE EYE'S *POSITION* ON THE BALL, A *SMALLER EYE* COMMUNICATES DIRECTION **BETTER.**

THE MORE WHITE AROUND THE EYE...

...THE MORE **EXACTLY** WE COMPREHEND ITS POSITION ON THE BALL...

...THE MORE **PRECISELY** WE GUAGE WHERE THE EYE IS LOOKING

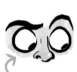

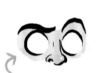

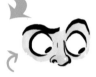

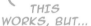

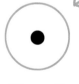

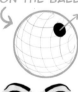

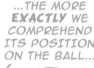

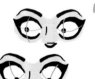

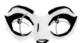

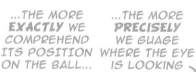

USE NARROWED EYELIDS AS A DIRECTION CUE

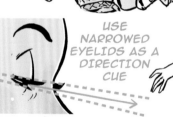

HANDS AND BODY LANGUAGE SUPPORT EYE LINE

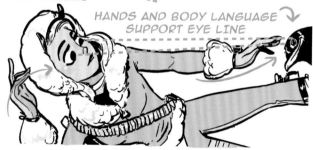